CONFEDERATE

SOUTH CAROLINA

CONFEDERATE

SOUTH CAROLINA

TRUE STORIES OF CIVILIANS, SOLDIERS AND THE WAR

Karen Stokes

THE
History
PRESS

Published by The History Press
Charleston, SC 29403
www.historypress.net

Front cover, bottom: House-Tops in Charleston During the Bombardment of Sumter, taken from the May 4, 1861 issue of *Harper's Weekly. Courtesy of the South Carolina Historical Society.*

Portions of chapters one and three were previously published in an article titled "Fort Sumter and the Siege of Charleston," *Confederate Veteran Magazine* 70 (January/February 2012): 16–65.

First published 2015

ISBN 978.1.5402.1266.5

Library of Congress Control Number: 2014953428

To the People of South Carolina,
Past and Present

"Lest We Forget"

CONTENTS

ACKNOWLEDGEMENTS

The wonderful manuscript collections of the South Carolina Historical Society in Charleston provided much of the material used in this book, and I am grateful for the privilege and joy of having worked with those collections for over twenty years. I owe thanks to archivist Mary Jo Fairchild for her prompt and gracious fulfillment of image requests; to J.R. Fennell, director of the Lexington County Museum, for allowing me to access and publish excerpts from the papers of John Fox; to the staff at the South Carolina Department of Archives and History in Columbia; and to William Stevens, who provided me with rare images of Mr. and Mrs. William Porcher DuBose. I am also indebted to Dr. James E. Kibler for his encouragement and helpful guidance on this project. Last but not least, I must thank my husband for his patience and unfailing support.

INTRODUCTION

On December 20, 1860, the state of South Carolina seceded from the United States and declared itself "an independent Commonwealth." Other Southern states followed its example, and in February 1861, they came together to form the Confederate States of America. For the next four years, most of which was spent in a vast, horrific, sacrificial struggle, the Palmetto State played a pivotal role in the new Confederacy and the war it was fighting for its independence. These years were marked by great drama, passion, heroism and tragedy, and perhaps no other Southern state paid a higher price for secession than South Carolina.

This book records the intriguing story of the state and its people between 1860 and 1865, and portions of it utilize the letters and diaries of the time to offer a compelling picture of the men and women who lived through this tumultuous period. Though these firsthand narratives often read like dramatic fiction, they are a faithful record of history as the participants saw it. *Confederate South Carolina* also explores some little-known events and individuals, chronicling, for example, the life and letters of Charleston's wartime British consul Henry Pinckney Walker, who observed the relentless siege of the city and lost a son in Confederate service just a month before the end of the four-year conflict.

Finally, the story of those years would not be complete without including some accounts of General Sherman's grim, destructive march in the winter of 1865, when South Carolina's homefront became a war front for thousands of civilians.

PRELUDE TO WAR: WHAT REALLY HAPPENED AT FORT SUMTER

Fort Sumter, located in the harbor of Charleston, South Carolina, is known as the place where the American "Civil War" began. The South is usually portrayed as the aggressor—that is, the side that fired the "first shot"—and is thus given the blame for starting the war. The whole truth is, however, that over a period of several months, the governments of South Carolina and the Confederate States of America made repeated efforts to settle the problem of Fort Sumter *peacefully* before any shots were fired. Though they knew that secession might bring on a conflict and made defensive preparations, the Southern leaders desired a peaceful separation from the union, not one bought with blood.

THE SECESSION CRISIS

In December 1860, South Carolina seceded from the United States and declared its independence. The Secession Convention, composed of delegates from throughout the state, assembled first in Columbia and then moved to Charleston because of a reported outbreak of smallpox in the capital city. In his book *The Genesis of the Civil War*, Samuel W. Crawford, a United States Army officer stationed in Charleston in 1860 (and later a Union general), described the excitement of the people of Charleston in contrast to the more sober nature of the convention itself:

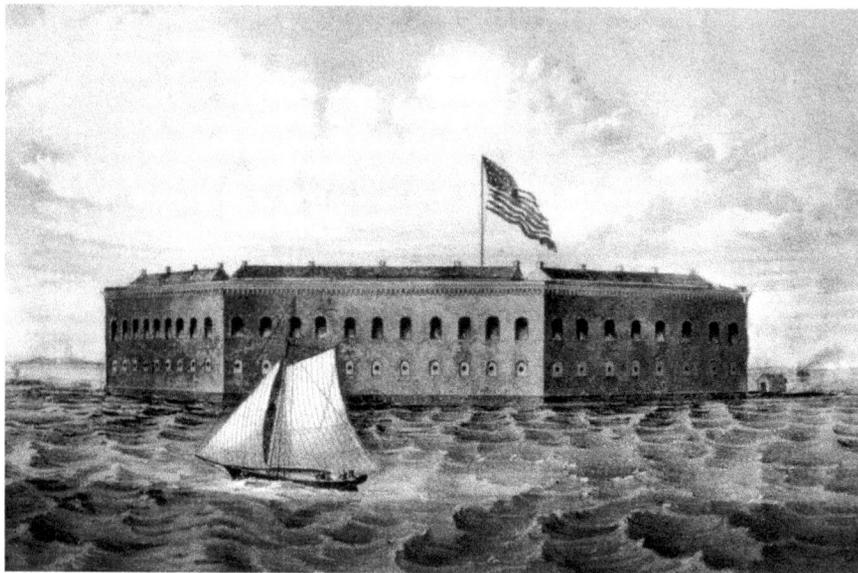

This lithograph by Currier & Ives is titled *Fort Sumter, Charleston Harbor, S.C. Library of Congress.*

There was a feverish anxiety to know that the secession of the State was really accomplished, and as the hour of noon approached, crowds of people streamed along the avenues towards St. Andrew's Hall and filled the approaches. A stranger passing from the excited throng outside into the hall of the Convention would be struck with the contrast...Quietly the Convention had met, and had been opened with prayer to God. There was no excitement. There was no visible sign that South Carolina was about to take a step more momentous for weal or woe than had yet been known in her history...The Convention moved in procession to Institute Hall, amid the crowds of citizens that thronged the streets, cheering loudly as it passed...The Hall was densely crowded...The President [of the convention] *then announced that "the Ordinance of Secession has been signed and ratified, and I proclaim the State of South Carolina,"* said he, *"an independent Commonwealth."*[1]

The long, complex history of conflict between the North and the South reached a fever pitch in 1860, and the documents produced by committees of the Secession Convention presented a number of South Carolina's grievances. The *Address of the People of South Carolina* compared the position of the South to that of the American colonists in 1776, stating:

The one great evil, from which all other evils have flowed, is the overthrow of the Constitution of the United States. The Government of the United States is no longer a Government of Confederated Republics...it is no longer a free Government, but a despotism. It is, in fact, such a Government as Great Britain attempted to set over our fathers; and which was resisted and defeated by a seven years' struggle for independence...The Southern States now stand exactly in the same position towards the Northern States that the Colonies did towards Great Britain. The Northern States, having the majority in Congress, claim the same power of omnipotence in legislation as the British Parliament...and the people of the Southern States are compelled to meet the very despotism their fathers threw off in the Revolution of 1776...

They [the Southern states] *are a minority in Congress. Their representation in Congress is useless to protect them against unjust taxation...For the last forty years, the taxes laid by the Congress of the United States have been laid out with a view of subserving the interests of the North...to promote, by prohibitions, Northern interests in the production of their mines and manufactures...The people of the Southern States are not only taxed for the benefit of the Northern States, but after the taxes are collected, three-fourths of them are expended at the North...*

No man can, for a moment, believe that our ancestors intended to establish over their posterity, exactly the same sort of Government they had overthrown...It cannot be believed, that our ancestors would have assented to any union whatever with the people of the North, if the feelings and opinions now existing amongst them, had existed when the Constitution was framed. There was then no tariff...African slavery existed in all the States but one. The idea that the Southern States would be made to pay tribute to their northern confederates which they had refused to pay to Great Britain; or that the institution of African slavery would be made the grand basis of a sectional organization of the North to rule the South, never crossed the imagination of our ancestors.

South Carolina, acting in her sovereign capacity, now thinks proper to secede from the Union...The right to do so is denied by her Northern confederates. They desire to establish a sectional despotism, not only omnipotent in Congress, but omnipotent over the States; and as if to manifest the imperious necessity of our secession, they threaten us with the sword, to coerce submission to their rule...[2]

The address further complained that "the Government of the United States has become consolidated, with a claim of limitless powers in its operations."[3]

The convention also produced a document titled the *Declaration of the Immediate Causes Which Induce and Justify the Secession of South Carolina from the Federal Union*. Citing "an increasing hostility on the part of the non-slaveholding States to the institution of slavery," the declaration defended states' rights, including the right of secession, and decried the existence of abolition societies in the North, which "sent emissaries, books and pictures" into the South to incite the slaves to violence against their owners.[4] The document also contended that the Northern states were not abiding by the Constitution or federal legislation regarding slaves by resisting the enforcement of the fugitive slave laws. The U.S. Constitution was viewed as a contractual agreement, or compact, that could be rendered null and void if any of the parties (i.e., the states) did not abide by their obligations. The declaration stated that "the constituted compact has been deliberately broken and disregarded by the non-slaveholding States, and the consequence follows that South Carolina is released from her obligation."[5]

Though many Northerners derided and even persecuted the proponents of abolitionism, especially in the earlier years of the movement, their influence increased, and in the 1850s, a series of events and publications further exacerbated sectional tensions, among them Harriet Beecher Stowe's book *Uncle Tom's Cabin*, published in 1852, and John Brown's raid at Harpers Ferry arsenal in Virginia in 1859. Brown planned to capture weapons at the armory and to lead an armed slave rebellion, and it was soon revealed that his raid had been funded by six prominent abolitionists in the North. All this made some Southerners anxious about their safety in the Union. In his book *Crisis of Fear*, historian Stephen Channing argued that fears and suspicions regarding Northern intentions after the raid contributed to the secessionist movement. Southerners were also shocked and angered that many Northerners admired John Brown and praised him as a martyr after his execution.[6]

Another cause for concern in the South was the formation of the Wide Awakes, a paramilitary organization of young men that formed in the North in the late 1850s and became closely affiliated with the Republican Party and the presidential election of 1860. The Wide Awakes wore uniforms, marched in the streets of Northern cities with torches and drilled as if preparing for military action. In September 1860, the *Richmond Enquirer* newspaper reported, "[T]he 'Wide Awakes' have their authority for believing that in the event of secession of Alabama or South Carolina it will be not only a pretext but a duty to march into Southern territory."[7] Historian Jon Grinspan noted that their militarism "sent an ominous message to those already apprehensive

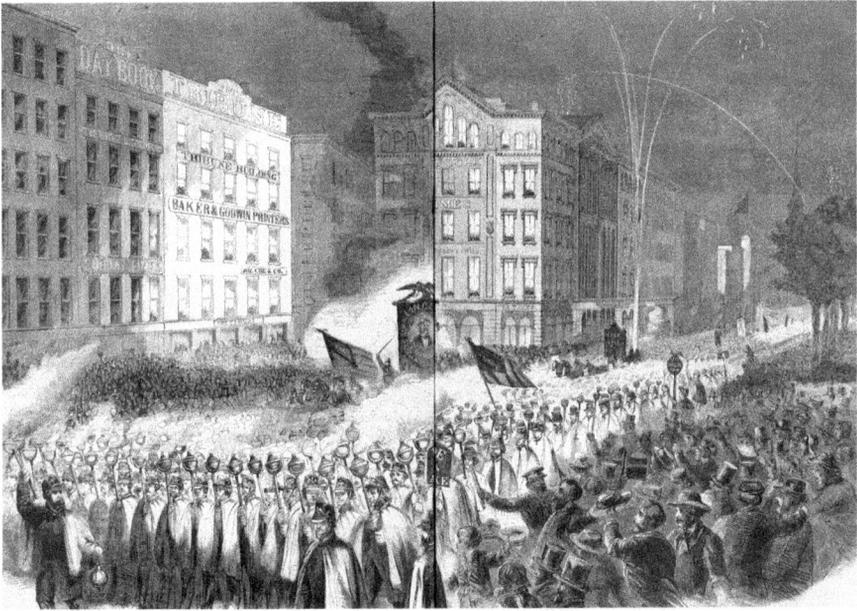

This illustration from an 1860 *Harper's Weekly* depicts a "Grand Procession of Wide-Awakes" in New York. *Library of Congress.*

about the Republican party's antisouthern attitudes."[8] Southerners began to organize "Minute Men" militia as a "direct response to the Wide Awakes."[9] In a sermon preached at Saint Peter's Episcopal Church in Charleston on November 25, 1860, Reverend William O. Prentiss mentioned the threat of the "Wide Awake organizations" of the North.[10] They were also brought up by delegate Edward McCrady during the Secession Convention in Charleston and might have been a factor on the minds of the delegates who authored *The Address of the People of South Carolina*, which asserted of the Northern states: "[T]hey threaten us with the sword, to coerce submission to their rule."[11]

The Republican Party platform of 1860 did not call for the abolition of slavery—in fact, it explicitly affirmed that any state had the right to maintain that institution—but it did oppose the expansion of slavery into the U.S. territories, a prohibition that the Southern states saw as an unconstitutional attack on their equality in the Union and an effort to diminish their political power. The Republican Party platform also called for changes in the tariff laws and for internal improvements. The promise of a protectionist tariff was a factor in the 1860 election and likely helped the Republicans secure crucial electoral votes that would win them the presidency in November.[12]

FORT SUMTER AND THE BEGINNING OF THE WAR

After the election of Abraham Lincoln, the candidate of a political party viewed by Southerners as purely sectional and concerned mainly with promoting the interests of the North, South Carolina proclaimed its independence on December 20, 1860. Less than a week later, Major Robert Anderson, the officer in command of the United States garrison at Fort Moultrie on Sullivan's Island, decided to move his men a short distance to Fort Sumter in Charleston Harbor. In the secrecy of night, the garrison spiked the cannons of Fort Moultrie, set the gun carriages on fire and took boats to the other fort. At about the same time, representatives from South Carolina arrived in Washington, D.C., commissioned to seek the removal of Major Anderson's garrison, to negotiate for a peaceful settlement of questions of Federal property within their state and to offer to pay South Carolina's share of the national public debt. News of the unexpected occupation of Fort Sumter, however, changed everything, and their mission was terminated.

Prior to this turn of events, in early December 1860, a delegation of congressmen from South Carolina (anticipating secession) had communicated with the president of the United States, James Buchanan, and assured him that there would be no attempt to take possession of the U.S. forts in South Carolina as long as the Federal government did not try to reinforce them and as long as no change was made in the status of the forts. They understood Buchanan to be in agreement with them on this, and consequently the South Carolina government was shocked by Major Anderson's move (which Buchanan said he had not authorized).

Just after occupying Fort Sumter, Major Anderson met with two militia officers sent by the governor of South Carolina and told them he was unaware of any agreement between President Buchanan and the South Carolina government concerning the status of the forts. Anderson said he had feared that an armed steamship patrolling the harbor would land men for an attack on Fort Moultrie and that the sole purpose for moving his garrison was "to prevent bloodshed." One of the South Carolina militia officers replied that the steamer patrol was there to monitor any attempts at reinforcement and that an attack on Anderson's men "was never entertained by the little squad who patrolled the harbor."[13]

The book *Gentlemen Merchants* by Philip N. Racine includes correspondence between Robert N. Gourdin, a prominent Charleston merchant, and his friend Major Anderson, written during the crucial months of December

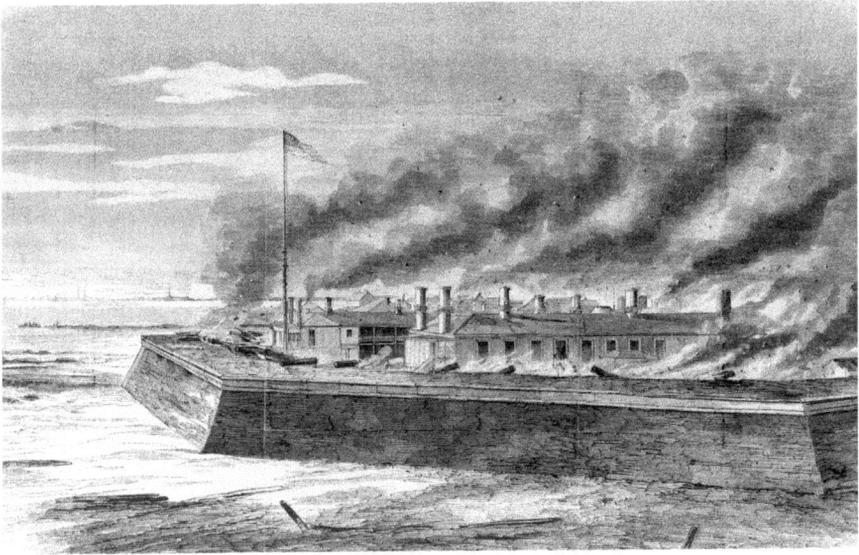

Fort Moultrie on Sullivan's Island. This illustration from *Frank Leslie's Illustrated Newspaper* shows the gun carriages aflame after Anderson's garrison evacuated the fort. *Library of Congress.*

1860 to April 1861. After Anderson's move to Fort Sumter, in a letter dated December 27, 1860, Gourdin expressed his profound sorrow over the major's decision and protested that the garrison had been in no danger at Fort Moultrie.

In response to Anderson's actions, the state took possession of the other harbor forts and the Federal arsenal in Charleston. Another incident that occurred shortly afterward increased tensions and was viewed by South Carolinians as a second hostile act. In early January 1861, the U.S. government attempted to reinforce and provision Fort Sumter, sending a civilian merchant ship named *Star of the West*, with armed troops and munitions concealed below its decks. Aware of its intentions and secret cargo, the South Carolinians fired on the ship, which reversed its course and steamed away.

Later in January, Francis W. Pickens, the governor of South Carolina, sent another envoy to Washington. This was Isaac W. Hayne, his attorney general, whose mission, as described by Jefferson Davis, was "to effect, if possible, an amicable and peaceful transfer of the fort, and settlement of all questions relating to property."[14] In the correspondence between Hayne and President Buchanan, there is a letter dated January 31, 1861, in which Hayne cautioned the president that the U.S. possession and

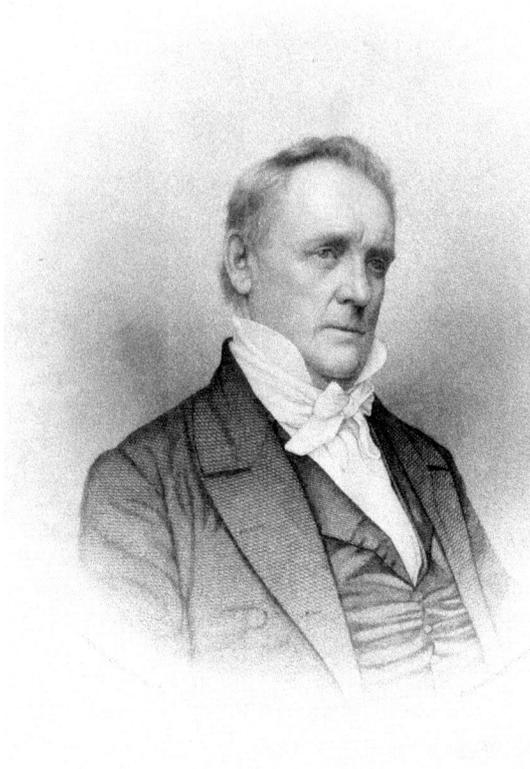

U.S. president James Buchanan (1791–1868). *Library of Congress.*

occupation of Fort Sumter, "if continued long enough, must lead to a collision."[15] A reply dated February 6, 1861, made to Hayne through Buchanan's secretary of war, Joseph Holt, stated that the purpose of Fort Sumter was the defense of Charleston Harbor and that if some "public enemy" menaced the city or the harbor, the fort's batteries would "be at once exerted for their protection."[16] Hayne found this idea absurd and wrote an indignant reply dated February 7:

> *You say that the fort was garrisoned for our protection and is held for the same purpose for which it has been held ever since its construction. Are you not aware, that to hold in the territory of a foreign power a fortress against her will, avowedly for the purpose of protecting her citizens is perhaps the highest insult which one government can offer to another? But Fort*

Sumter was never garrisoned at all until South Carolina had dissolved her connection with your Government. This garrison entered it in the night with every circumstance of secrecy after spiking the guns and burning the gun carriages and cutting down the flag-staff of an adjacent fort which was then abandoned. South Carolina had not taken Fort Sumter into her own possession only because of her misplaced confidence in a government which deceived her.[17]

Following the instructions of his commission, Hayne demanded the removal of the garrison and offered a pledge from his state that the United States government would be compensated for the monetary value of Fort Sumter and its contents. But as Davis recorded, he "was met only by evasive and unsatisfactory answers, and eventually returned without having effected anything."[18]

From the later part of January until the end of the first week of April, under an agreement with South Carolina governor Pickens, Major Anderson and his men, who were running low on certain supplies (most importantly fresh meat and vegetables), were permitted to receive food and other provisions from the Charleston markets, as well as their mail. On December 29, 1860, Anderson wrote to Robert N. Gourdin, saying, "I have supplies of provisions, of all kinds, to last my command about five months, but it would add to our comfort to be enabled to make purchases of fresh meat and so on, and to shop in the city."[19] Gourdin's letters reveal that he helped with the arrangements for the delivery of letters, food, candles, tobacco and other supplies (Klinck, Wickenburg & Company providing groceries). In the Hayne correspondence, a letter from Joseph Holt dated January 22, 1861, acknowledges that "Major Anderson and his command do now obtain all necessary supplies, including fresh meat and vegetables, and I believe fuel and water, from the city of Charleston."[20] In late February, Captain John G. Foster of the Fort Sumter garrison reported in an official letter, "Our supplies and mails come from town as usual."[21] These privileges continued until April 7, when it was learned that Federal warships were being sent to Charleston Harbor.

In February 1861, the Confederate States of America was formed (provisionally at first) in Montgomery, Alabama, and Jefferson Davis of Mississippi was elected as president. The following month, Abraham Lincoln took office as president of the United States. In his inaugural address, he stated that he had no right or intention to interfere with slavery.[22] He did say, however, that he would use force "to hold, occupy, and possess the property and

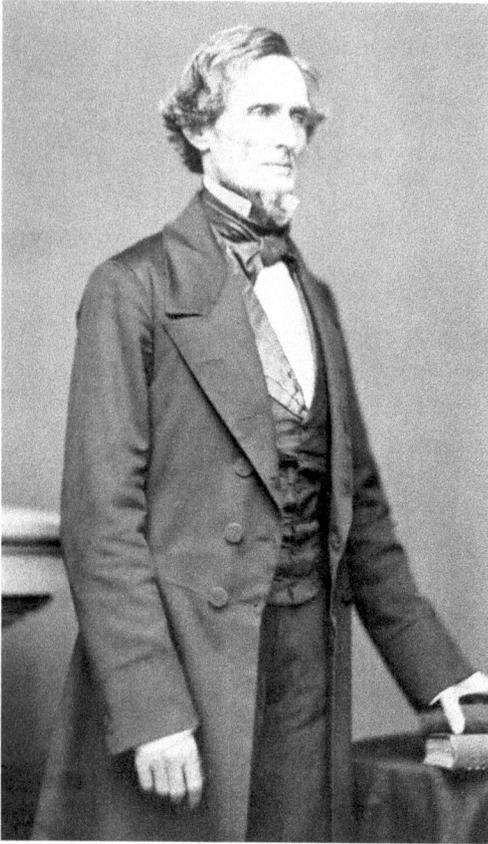

Jefferson Davis (1808–1889), president of the Confederate States of America. *Library of Congress.*

places belonging to the [U.S.] government, and to collect the duties and imposts" (duties and imposts meaning the tariff revenue on imports).[23] The leaders of the new Confederacy interpreted this to mean war—nevertheless, hoping to avoid an armed conflict, President Davis sent three commissioners to Washington to negotiate the same matters that the earlier representatives from South Carolina had been sent to discuss, to seek recognition of the Confederate States as a sovereign nation and to establish friendly relations between the two powers. President Lincoln did not meet with these men, and his administration would not agree to any negotiations or any recognition of their government.

In March 1861, U.S. Supreme Court justice John Campbell, who was acting as an unofficial intermediary between the Confederate commissioners and U.S. secretary of state William H. Seward, was assured by Seward more than once that Fort Sumter would be evacuated. The Confederate authorities in Montgomery and Charleston hoped that the Federal garrison would be taken out of Fort Sumter so that the impending horror of war could be averted, and Major Robert Anderson hoped for the same outcome. In his diary, Abner Doubleday, one of the garrison officers, recorded that Anderson "had no doubt that we would be withdrawn."[24]

As time passed, the Confederates put less and less faith in Seward's assurances, and while the nation watched and waited to see what the outcome of the Fort Sumter crisis would be, newspapers speculated about Lincoln's intentions. On April 5, 1861, the *New York Herald* newspaper

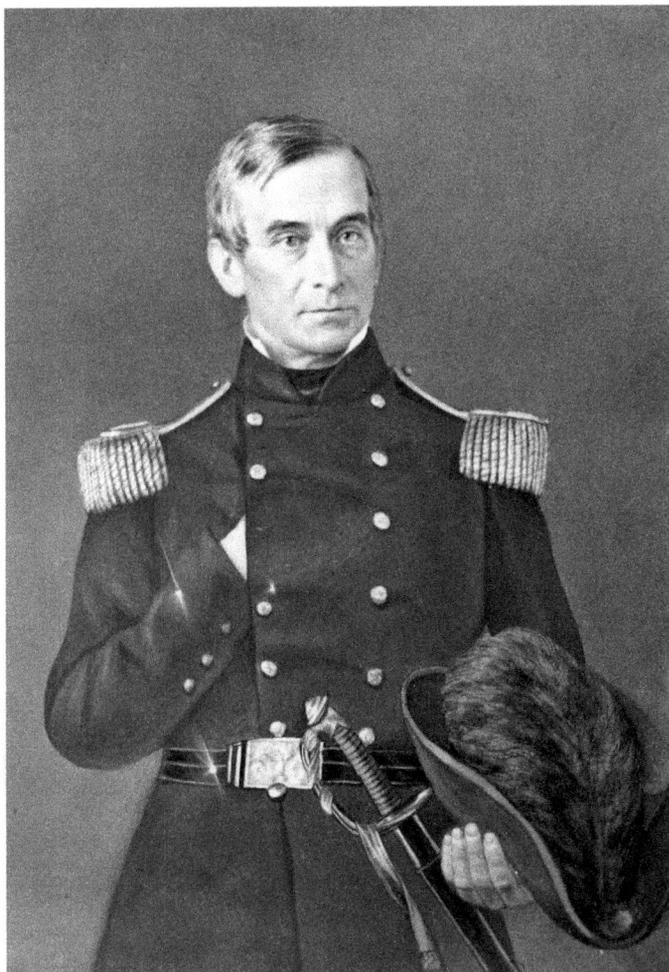

Major Robert Anderson (1805–1871). *Library of Congress.*

editorialized: "We have no doubt Mr. Lincoln wants the [Confederate] Cabinet at Montgomery to take the initiative by capturing…forts in its waters, for it would give him the opportunity of throwing the responsibility of commencing hostilities."[25]

Reporting part of a message received from Confederate president Davis, the same newspaper observed on April 7: "Unless Mr. Lincoln's administration makes the first demonstration and attack, President Davis says there will be no bloodshed. With Mr. Lincoln's administration, therefore, rests the responsibility of precipitating a collision, and the fearful events of protracted war."[26]

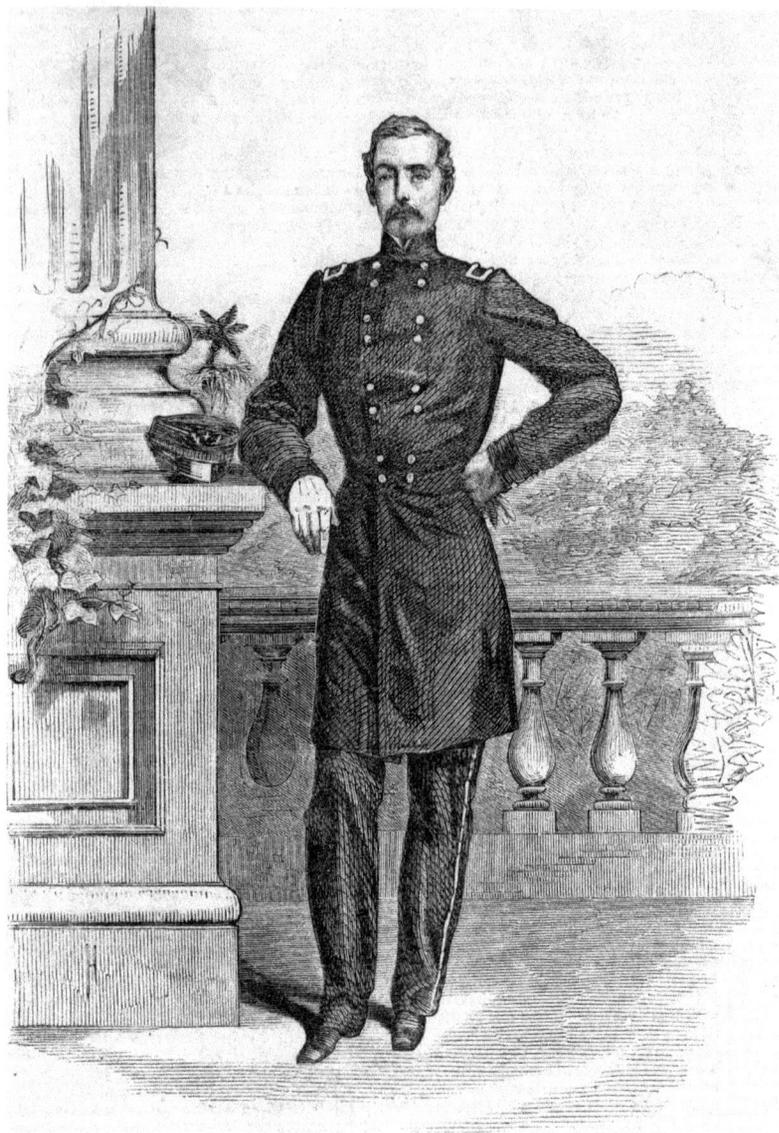

General Pierre Gustave Toutant Beauregard (1818–1893). *Library of Congress.*

On April 8, a special messenger from the U.S. State Department delivered a message to Governor Pickens written by President Lincoln. It notified the governor to expect an armed naval expedition that would attempt to supply Fort Sumter with provisions, by force if necessary.

The correspondence of General P.G.T. Beauregard, the Confederate commander at Charleston, clearly shows that Major Anderson's food supplies from the city were cut off on April 7. On April 8, Beauregard was instructed by his superiors, "Under no circumstances are you to allow provisions to be sent to Fort Sumter."[27] The general replied in a communication of the same date, "Anderson's provisions stopped yesterday."[28] By this time, the U.S. ships and troops were on their way to Charleston Harbor. Historian John V. Denson pointed out, "Lincoln had already issued the orders to reinforce Fort Sumter and was using the pretext that he was 'sending bread to the starving garrison,' when in fact, it was not until April 7 that the South cut off Anderson's food supply, and this was entirely the result of provocative acts of the president."[29]

President Davis concluded that the strengthening of a fortress that could be used against Charleston and the harbor batteries could not be tolerated and that it should be reduced before it could join forces with the approaching warships. On April 10, General Beauregard sent a message to Major Anderson requesting him to evacuate the fort. Anderson refused to leave, but the Confederate authorities, still reluctant to bombard the Fort Sumter garrison, gave Anderson another chance the following day, asking him again to evacuate and allowing him to choose his own time to do so. Anderson replied that he would evacuate by noon on April 15, but only on the condition that the Confederates did not commit "some hostile act against this fort or the flag of my Government" in the meantime.[30] However, by this time (April 11), Federal ships were already arriving off Charleston Harbor and would have had three days to resupply and possibly reinforce Fort Sumter without interference under these terms, and so they were refused. The next day, the Confederates began a bombardment.

Of the decision to bombard the fort, Jefferson Davis later wrote:

The attempt to represent us [the South] *as the aggressors in the conflict which ensued is as unfounded as the complaint made by the wolf against the lamb in the familiar fable. He who makes the assault is not necessarily he that strikes the first blow or fires the first gun. To have awaited further strengthening of their position by land and naval forces, with hostile purpose now declared, would have been as unwise as it would be to hesitate to strike down the arm of the assailant, who levels a deadly weapon at one's breast, until he has actually fired. The disingenuous rant of demagogues about "firing on the flag" might serve to rouse the passions of insensate mobs in times of general excitement, but will be impotent in impartial history to*

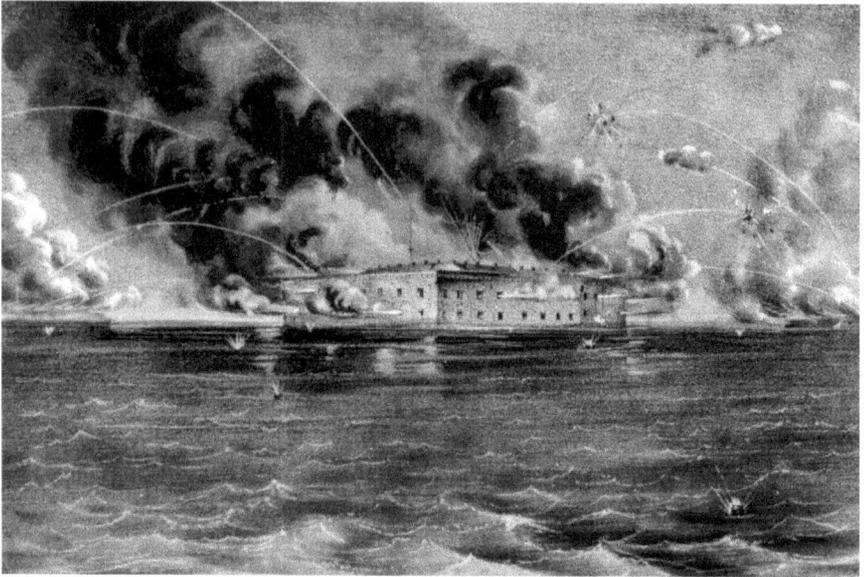

This well-known lithograph by Currier & Ives depicts the bombardment of Fort Sumter in April 1861. *Library of Congress.*

relieve the federal government from the responsibility of the assault made by sending a hostile fleet against the harbor of Charleston, to cooperate with the menacing garrison of Fort Sumter.[31]

Throughout the bombardment, the newly arrived Federal vessels—including the warship *Pawnee*, an armed cutter; the *Harriet Lane*; and the *Baltic*, a transport ship—lay off the bar. None of them entered the harbor to brave the guns firing from the Confederate harbor batteries, and they rendered no assistance to the besieged fort.[32] Davis said the ships were prevented from entering the harbor "only by a gale of wind."[33] The warship *Pocahontas* arrived on April 13 and found the other vessels at anchor.[34]

In New Jersey, the *American Standard* newspaper stated on April 12 that the Lincoln administration sought to mask its real purpose by pretending that it was merely acting out of humanitarian motives in succoring Major Anderson and his garrison. The editor went on to say:

The measure is a disingenuous feint…a mere decoy to draw the first fire from the people of the South, which act by the pre-determination of the government is to be the pretext for letting loose the horrors of war. It dare not

*itself fire the first shot or draw the first blood, and is now seeking by a mean
artifice to transfer the odium of doing so to the Southern Confederacy...*[35]

On April 16, 1861, the *Buffalo Daily Courier* editorialized, "The affair at
Fort Sumter, it seems to us, has been planned as a means by which the war
feeling at the North should be intensified, and the [Lincoln] administration
thus receive popular support for its policy...War is inaugurated, and the
design of the administration is accomplished."[36]

An incident of the bombardment that is not very well known was
described by James Chester, an officer of the Fort Sumter garrison, in
his article "Inside Sumter in '61." He describes how, four hours into
the artillery duel, some of the gunners under the command of Captain
Abner Doubleday noticed a crowd of spectators gathered on nearby
Sullivan's Island:

*A large party, apparently of non-combatants, had collected on the beach of
Sullivan's Island, well out of the line of fire, to witness the duel between
Sumter and Moultrie. Doubleday's men were not in the best of temper.
They were irritated that they had been unable to inflict any serious damage
on their adversary, and although they had suffered no damage in return they
were dissatisfied.*[37]

While their higher officers were not present, the gun crew loaded two
"42-pounders," directed their aim at the crowd and fired. The first cannon
ball missed the spectators but struck the beach about fifty yards in front of
them, bounded over their heads and crashed into the Moultrie House, a
hotel. The second shot followed much the same course.

The shelling of Fort Sumter resulted in no deaths of the combatants,
and on April 13, Major Anderson surrendered, and he and his men were
treated respectfully and allowed safe passage home. Two days later, President
Lincoln called up troops for the suppression of the "insurrection." It was not
until this call for troops went out, and an intended invasion of the South
was made plain, that the states of Virginia, Tennessee, North Carolina and
Arkansas seceded in outrage.

When asked for troops from his state, Governor Ellis of North Carolina
promptly telegraphed an answer to Lincoln, stating, "I regard the levy of
troops made by the administration for the purpose of subjugating the states
of the South, as a violation of the constitution, and as a gross usurpation of
power. I can be no party to this wicked violation of the laws of this country

and to this war upon the liberties of a free people. You can get no troops from North Carolina."[38]

The governors of the other seceded states, including Virginia, sent similar answers to Washington.

Chapter 2

THE FEDERAL OCCUPATION OF
BEAUFORT AND COLUMBIA

BEAUFORT

The beautiful town of Beaufort, located on Port Royal, a sea island south of Charleston, was captured by U.S. forces in the first year of the war. *Sea Island Lands*, a pamphlet attributed to Richard DeTreville, a Beaufort attorney, gives the following description of the place:

> *At this time...the Town of Beaufort was one of the most desirable residences on the sea coast of South Carolina. Its inhabitants, about twelve or fifteen hundred whites, were as a whole extremely well educated, and many of them most honorably identified with the past glory of the old State. They were hospitable and unsuspicious, and as a society distinguished by a very high degree of refinement and elegance, intellectually and morally. More than one hundred and fifty years back their ancestors had settled it...With a few exceptions they were, as had been their forefathers, planters living on the production of their lands. Their residences [were] tastily located and handsome, some of them expensive and luxurious.* [39]

In November 1861, Confederate batteries on each side of the entrance to Port Royal Sound offered resistance to a massive Union naval fleet but were unable to check its progress. The ships continued on to Beaufort and found the place emptied of its white inhabitants, who had evacuated when they

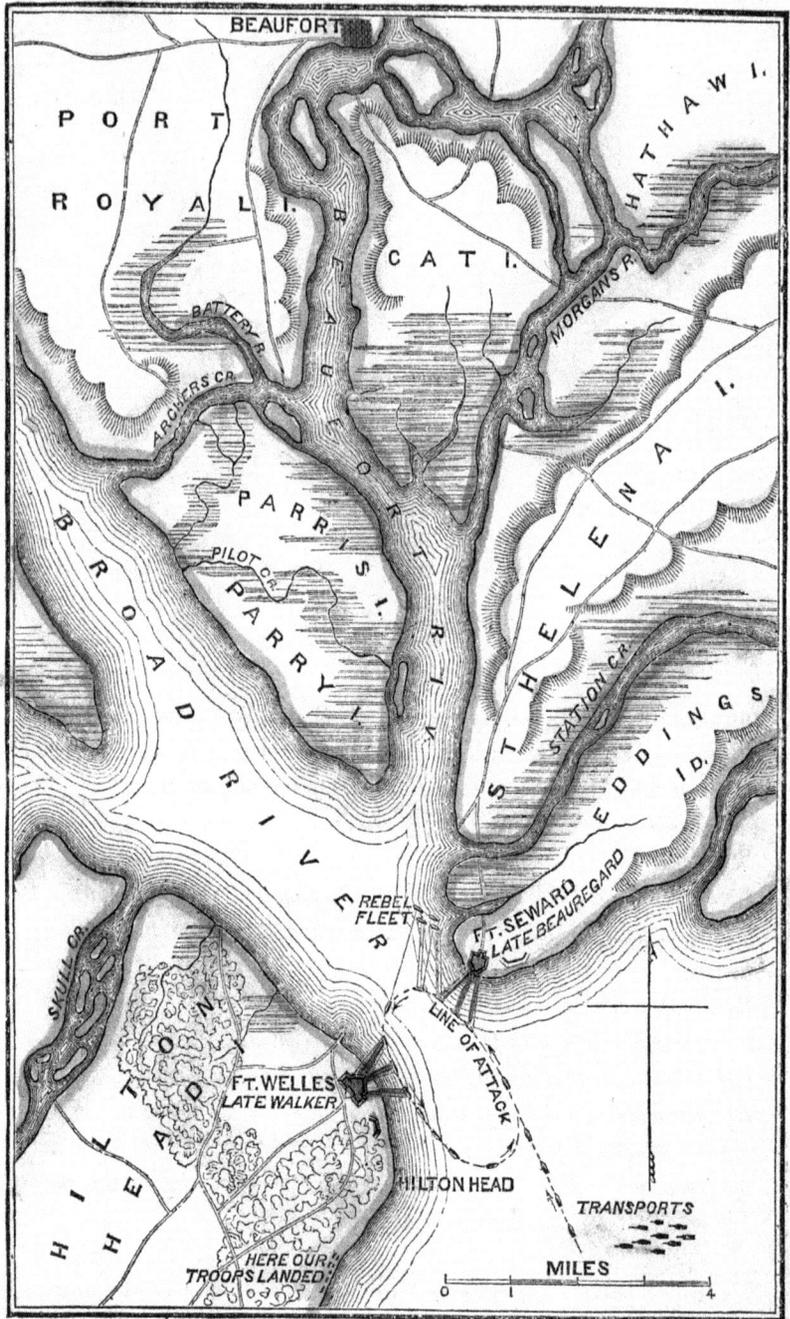

Map of the Port Royal area, including Beaufort and Hilton Head, created sometime after November 1861. The Confederate forts Walker and Beauregard have been renamed by the Federal occupying army. *From the author's collection.*

heard of the approach of the Federal fleet. A historical sketch of St. Helena (the parish in which Beaufort was located) recorded of this time:

On the 7th of November, 1861, the Federal fleet passed the forts at the entrance of Port Royal harbor, and within a few hours the entire white population had deserted Beaufort. A dread of being cut off from their fathers, brothers, husbands and sons was what inspired the people. The movement was so rapid and complete that a young Confederate officer who escaped from one of the lower batteries assured the writer that passing through some of the most frequented streets of Beaufort he saw but one white man, a foreign merchant. [40]

DeTreville's pamphlet reported how the area, including the islands of Hilton Head and St. Helena, was taken over and occupied by Northern troops, merchants and speculators: "The port was thrown open to the vessels of all nations. A custom-house was established at Hilton Head, and a post-office and a newspaper called the *New South* established in the town…" [41]

This document also described how the houses of Beaufort and environs were emptied of their costly furnishings, which were "destroyed, or sold to the shopkeepers and shipped North." [42] One Union officer observed, "The plunder was not all obtained by soldiers, but officers received a fair share…Some of them sent north pianos, elegant furniture, silver-ware, books, pictures, &c., to adorn their New England dwellings." [43]

As early as November 11, 1861, the general commanding the U.S. Expeditionary Corps at nearby Hilton Head Island wrote a letter to a U.S. congressman (the chairman of the Military Committee) reporting that some of his troops "have, without orders, invaded the premises of private individuals and committed gross depredations upon their property, and…that some commissioned officers…have not only connived at these outrages, but have actually participated in them." [44]

In addition, Beaufort's fine public library was crated up and put on a ship bound for New York, never to return to South Carolina. The town's library had originally consisted of over five thousand volumes, but after vandalism and pillage, only about three thousand remained when they were shipped north in November 1862. The books were subsequently advertised for sale in New York newspapers in the following terms:

MONDAY EVEN'G. Nov. 17th, at 6½ o'clock. And the Succeeding Evenings of the Week. Government Sale. CATALOGUE of an immense

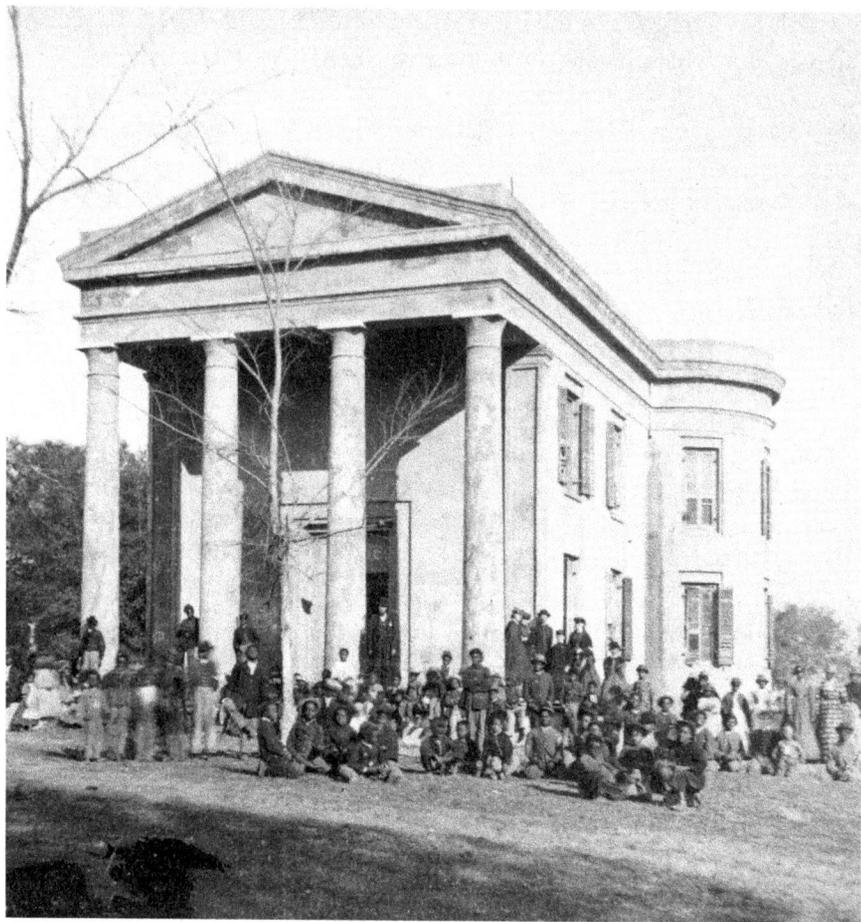

This photograph, dating to about 1862, shows some of the local African American children and their teachers assembled in front of Beaufort College, the site of the Beaufort Library Society. *Library of Congress.*

collection of LIBRARY BOOKS. In all departments of Literature, Arts and Sciences, including very many important and scarce works, &c. TO BE SOLD AT AUCTION. By order and under the Direction of HIRAM BARNEY, Esq., Collector of the Port of N.Y. ON MONDAY EVENING, NOV. 17ᵗʰ, 1862. And the succeeding evenings of the week. BY BANGS, MERWIN & CO., at the Irving Buildings, 594 and 596 BROADWAY, Sale to Commence at each Evening at 6½ o'clock precisely. Terms—Cash, in Bankable Funds. Gentlemen who cannot attend the Sale may have their orders to purchase executed by the Auctioneers.[45]

After this advertisement appeared, the people and press of New York made such an outcry that the U.S. government postponed the sale of the Beaufort library and sent the books to the Smithsonian Institution for storage. There, in January 1865, they were lost in a fire.[46]

The slaves of the Port Royal area were given a measure of freedom by the occupying military and governmental authorities and were aided and educated by Northern charitable organizations, but they were not well treated by many of the soldiers. The *New York Tribune* newspaper, which had a war correspondent in the Beaufort area, reported in an article that appeared in its December 7, 1861 issue that "one enterprising and unscrupulous [Federal] officer was caught in the act of assembling a cargo of Negroes for transportation and sale in Cuba."[47]

In 1862, General David Hunter, commander of the U.S. Department of the South, issued an order abolishing slavery in the part of South Carolina under Federal control, but it was immediately rescinded by President Lincoln. In May of that same year, Hunter issued another order to conscript "every able-bodied negro between the ages of eighteen and forty-five, capable of bearing arms."[48] His effort to raise black troops was also overruled by the U.S. president, and this group was mostly disbanded by August. The black men who formed the First South Carolina Colored Infantry in 1862 under Hunter's orders were inducted involuntarily, and some observers noted that the scenes that occurred when these men were initially taken from their homes were very distressing. Edward L. Pierce, a U.S. Treasury agent at the Pope plantation on St. Helena (a sea island located about four miles from Beaufort), observed in a letter of May 12, 1862:

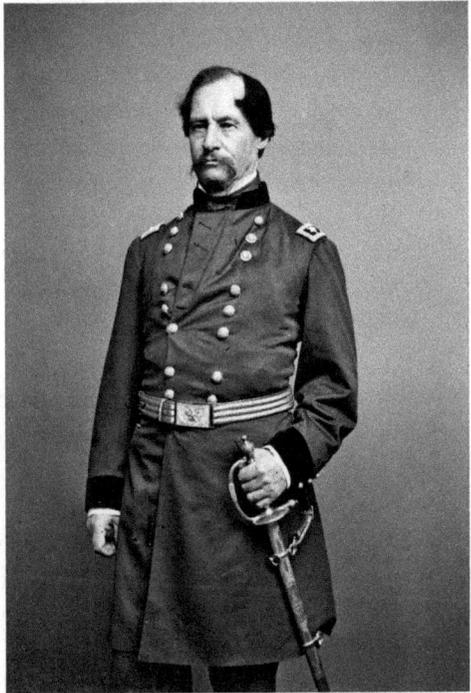

General David Hunter (1802–1886). *Library of Congress.*

This has been a sad day on these islands…Some 500 men were hurried during the day from Ladies and Saint Helena to Beaufort, taken over in flats and then carried to Hilton Head…The negroes were sad enough… Sometimes whole plantations, learning what was going on, ran off to the woods for refuge. Others, with no means of escape, submitted passively to the inevitable decree…The arming of these negroes by entirely voluntary enlistments is well, but this mode of violent seizure and transportation even to Hilton Head alone, spreading dismay and fright, is repugnant.[49]

The next day, Pierce wrote to General Hunter, adding the following details:

The colored people became suspicious of the presence of the companies of soldiers detailed for the service, who were marching through the islands during the night…They were taken from the fields without being allowed to go to their houses even to get a jacket…The inevitableness of the order made many resigned, but there was sadness in all. As those on this plantation were called in from the fields, the soldiers, under orders, and while on the steps of my headquarters, loaded their guns, so that the negroes might see what would take place in case they attempted to get away…Wives and children embraced the husband and father thus taken away, they knew not where, and whom, as they said, they should never see again. On some plantations the wailing and screaming were loud and the women threw themselves in despair on the ground. On some plantations the people took to the woods and were hunted up by the soldiers…I doubt if the recruiting service in this country has ever been attended with such scenes before.[50]

In October 1862, General Rufus Saxton, the military governor of the Department of the South, was authorized to raise five thousand colored troops, and nearly five hundred black men had enlisted by December 1862. Two years later, however, in December 1864, Saxton wrote disapprovingly to U.S. secretary of war Edwin M. Stanton concerning the "recruiting" of African Americans into the Union army by another officer, as well as other matters regarding their treatment by U.S. forces. The "major-general" Saxton refers to is General John G. Foster, who assumed command of the Federal Department of the South at Hilton Head in May 1864. White soldiers under Foster's command "enlisted" many black men and boys by force and would shoot down those who resisted.[51] Saxton wrote:

*I report...my doings for the current year...[T]he recruiting went on slowly,
when the major-general commanding...ordered an indiscriminate conscription
of every able-bodied colored man in the department...The order spread
universal confusion and terror. The negroes fled to the woods and swamps,
visiting their cabins only by stealth and in darkness. They were hunted to
their hiding places...Men have been seized and forced to enlist who had large
families of young children dependent upon them for support...*

*Three boys, one only fourteen years of age, were seized in a field where
they were at work and sent to a regiment in a distant part of the department
without the knowledge or consent of their parents. A man on his way to
enlist as a volunteer was stopped by a recruiting party. He told them where
he was going and was passing on when he was ordered to halt. He did
not stop and was shot dead, and was left where he fell. It is supposed the
soldiers desired to bring him in and get the bounty offered for bringing in
recruits. Another man who had a wife and family was shot as he was
entering a boat to fish, on the pretense that he was a deserter. His wound,
though very severe, was not mortal...*

*I found the prejudice of color and race here in full force, and the general
feeling of the army of occupation was unfriendly to the blacks. It was
manifested in various forms of personal insult and abuse, in depredations
on their plantations, stealing and destroying their crops and domestic
animals, and robbing them of their money.*

*The women were held as the legitimate prey of lust...Licentiousness
was widespread...There was a general disposition among the soldiers and
civilian speculators here to defraud the negroes in their private traffic, to
take the commodities which they offered for sale by force, or to pay them in
worthless money.*[52]

In the same report, the general also noted that lands belonging to the former white residents of the area had been sold at auction and were "in the hands of private persons or under the control of the U.S. direct-tax commission."

In October 1862, Esther Hill Hawks, a Northern female physician and teacher who worked for the Freedmen's Aid Society in Beaufort, noted in her diary how disgracefully the black people were treated by the Federal soldiers. She observed how "no colored woman was safe from the brutal lusts of the soldiers" and emphasized that these soldiers were both officers and enlisted men (in particular those of the Fifty-fifth Pennsylvania Regiment), who were not punished for their offenses.[53] In her diary, she described the case of an old black woman who was shot in the shoulder for trying to protect

her daughter, adding that there were other women in the hospital who had been shot for resisting the "vile demands" of the soldiers. She also recorded that one of the higher officers, a Colonel Richard White, "for a long time, kept colored women for his special needs—and officers and men were not backward in illustrations of his example."[54]

In November 1861, John Bessemer, a U.S. soldier stationed in the area, witnessed some eight to ten soldiers of the Forty-seventh New York Regiment try to chase down some black women and then catch and rape a black girl about nine years of age.[55] Esther Hill Hawks recorded in her diary in late 1862 that such "open atrocities" against black women had become "quite rare," but General Saxton's report of 1864 indicates that the black women continued to be the "prey of lust."[56]

St. Helena's Episcopal Church in Beaufort suffered damages during the war by the occupying army. According to an 1868 report concerning depredations to church property, "the Federal forces converted the building into a hospital, removed the pews and galleries, and floored it across so as to form a second story." The church was also looted and vandalized, as Esther Hill Hawks and other contemporary observers noted. Many years after the war, the parish church was able to recover one of its stolen vestry minute books dating from 1726 to 1812. According to historian A.S. Salley, "During the war between the United States and the Confederate States this book disappeared. In 1902 Theodore Hawley wrote [to me] from New Canaan, Connecticut…sent [me] this book and offered to sell it…stating that he had purchased it at an auction sale in the North. After some negotiations between officers of the church, in Beaufort, and the holder of the book, the latter was purchased by Mr. Charles M. Barnwell and returned to its rightful owners."[57]

Occupied Beaufort and Hilton Head remained in U.S. control until the end of the war. From these points, forays and foraging expeditions were launched into the surrounding areas. On February 5, 1862, John F. Holahan, a Federal soldier, recorded the details of an expedition to Spring Island, noting the vandalism committed by soldiers of his army at the Edwards family mansion.[58] In June 1863, Colonel William B. Barton landed a force at nearby Bluffton on the May River, and by his orders, much of the town was "destroyed by fire, the church only being spared."[59] In a memoir found in the papers of Edward H. Mellichamp, Mary Mellichamp Woodward wrote of her family's experiences during the destruction of Bluffton, describing how Federal soldiers pillaged and vandalized her home, destroying chandeliers, mirrors, paintings, china and furniture. She also recorded that a watch on a silk cord was "jerked from the neck of my old grandfather" and that her

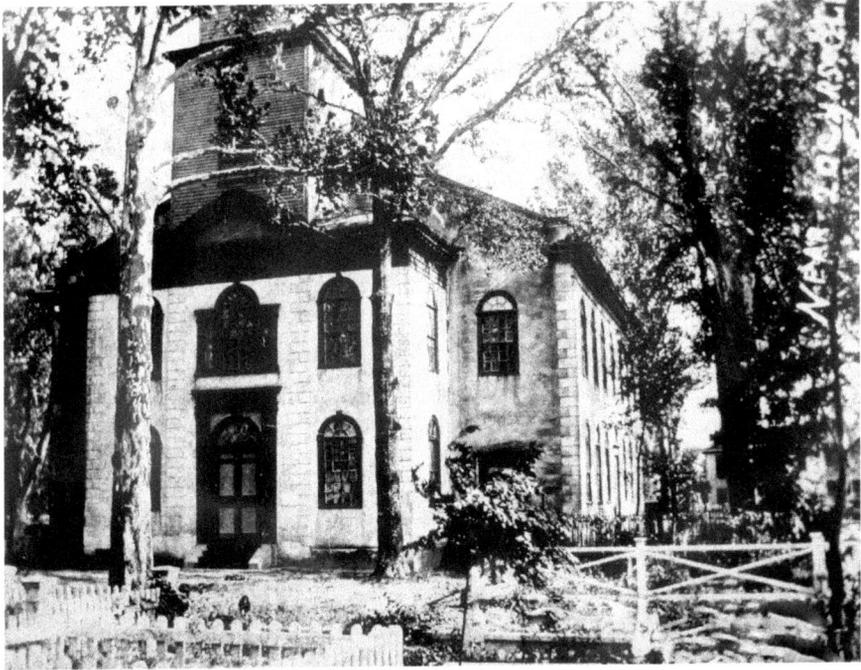

St. Helena's Episcopal Church in Beaufort as seen in a photograph of 1900. *Library of Congress.*

black nurse "was beaten into insensibility when she repulsed the advances of a soldier."[60]

In another village near Beaufort, McPhersonville, Federal soldiers committed crimes described as "hellish outrages and burglary" in 1864. On November 24 of that year, Beaufort's Union newspaper, the *New South*, published an account of the execution of two Federal soldiers, Private James Grippen (or Gripon), Company F, 104th USCT, and Private Benjamin Redding of the same regiment, who, along with other unidentified soldiers, plundered two houses, raped several women who lived there, attempted to murder a male family member and then burned one of the dwellings. The paper goes on to state, "These two fiends were soon after arrested and finally brought before a General Court Martial, held at Headquarters, Department of South Carolina, Hilton Head, October 26th on charges of rape, burglary and arson."[61]

Grippen and Redding were found guilty and executed by hanging in November 1864. The *New South* recounted their execution thusly:

At the execution…at the Federal post on Hilton Head Island, Grippen was asked by the Federal officer Lieut. Charles F. Richards "if he had anything to say; if he had, he would repeat it to the assembly." He replied that he confessed his guilt, and warned all those present, more particularly the colored troops, and his own company, which were present, "not to be led away by strange men; but to do right, and they would not be where he was now." He also wished them all good-bye. Redding, though nearly exhausted, desired the officer to warn all "to be good" and bid them all "good-bye."[62]

The other soldiers who had committed crimes in company with Grippen and Redding were never brought to justice.[63]

The Capture and Burning of Columbia

In February 1865, during its march through the Carolinas, the army of General William T. Sherman took possession of Columbia, the capital city of South Carolina. Much of the city was burned at this time, and its mayor, Thomas Jefferson Goodwyn, wrote to the governor of South Carolina, Andrew G. Magrath, to inform him of conditions there. In a letter dated March 2, 1865, the mayor reported:

It is with great grief that I communicate our terrible calamity. At least four fifths of our city is in ashes, very little of the valuable part left with the destruction of our houses. The vandals destroyed near[ly] all the furniture & nearly all the provisions they could not carry off. When the enemy left us, with a view to white wash their savageness, they left us five hundred head of cattle. The cattle was so poor that they could not drive them off. They are dying daily on our hands; what wheat was left in one mill that was not burnt, we are grinding & dividing amongst our people (with the poor cattle). We are building flats on the Congaree & Broad rivers & look to the up country people to help us…We have been (truly) badly & cruelly treated, by a lying & savage foe. They promised perfect protection (Sherman) to all private property & persons, when it can be proved that they contemplated our utter destruction weeks before they came here.[64]

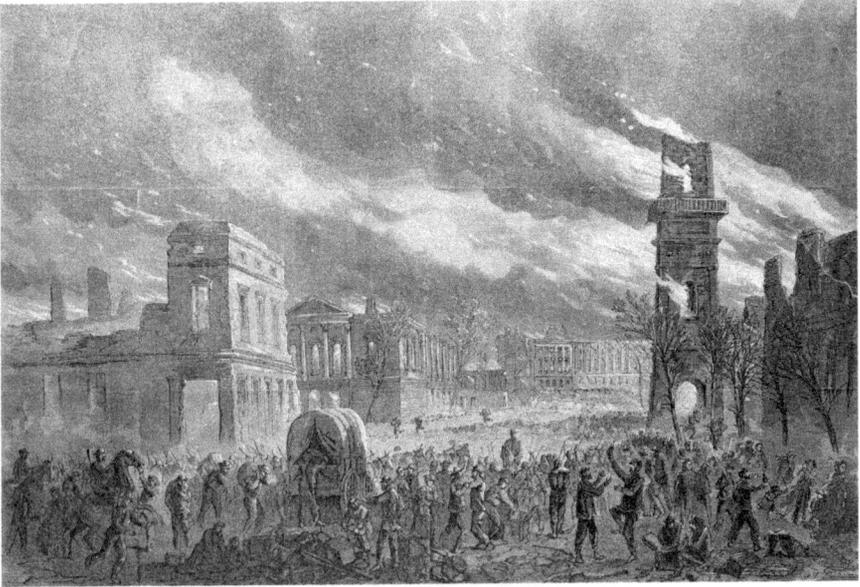

This powerful illustration of the burning of Columbia by William Waud appeared in *Harper's Weekly* in April 1865. *Library of Congress.*

In a postscript, Goodwyn added, "We are now feeding seven thousand people daily rations that have nothing themselves. I have just been notified by the Physician of the Asylum that he will have to draw tomorrow for that institution."

About two years later, a committee of Columbia citizens was formed "to collect evidence as to the burning of the city on the night of February 17, 1865."[65] The committee accepted statements from only those persons who would make sworn affidavits of their experiences and observations. The committee collected more than sixty depositions and compiled a report based on them. The report was presented to Mayor McKenzie, who served from 1868 to 1870, but afterward, the Republican (carpetbagger) administration had possession of the city archives for about a decade. In 1878, when a search was made for the original committee report and affidavits concerning the burning of Columbia, they could not be found. There were no duplicates of the sworn affidavits, but fortunately, other copies of the report existed, and the following extracts from it document the testimony of many eyewitnesses:

More than sixty depositions and statements in writing, from as many individuals, have been placed in the hands of the Committee. The array of

witnesses is impressive, not merely because of their number, but for the high-toned and elevated character of some of them, the unpretending and sterling probity of others, and the general intelligence and worth of all.

The forces of General Sherman's command while in Georgia seem to have anticipated that their next march would be through South Carolina. Their temper and feelings towards our people, a witness, Mrs. Catherine L. Joyner, thus describes: "The soldiers were universal in their threats. They seemed to gloat over the distress that would accrue from their march through the state. I conversed with numbers of all grades, belonging to the Fourteenth and Twentieth Corps. Such expressions as the following were of hourly occurrence: 'Carolina may well dread us. She brought this war on, and shall pay the penalty. You think Georgia has suffered, just wait until we get into Carolina; every man, woman and child may dread us there.'" Of General Sherman himself, the same witness informs us that, addressing himself to a lady of his acquaintance, he said to her: 'Go off the line of railroad, for I will not answer for the consequences where the army passes.'"

The threats uttered in Georgia were sternly executed by the troops of General Sherman upon their entrance into this State…As he advanced, the villages of Hardeeville, Grahamville, Gillisonville, McPhersonville, Barnwell, Blackville, Midway, Orangeburg and Lexington were successively devoted to the flames. Indignities and outrages were perpetrated upon the persons of the inhabitants. The implements of agriculture were broken; dwellings, barns, mills, gin-houses, were consumed; provisions of every description appropriated or destroyed; horses and mules carried away; and sheep, cattle and hogs were either taken for actual use, or shot down and left behind. The like devastations marked the progress of the invading army from Columbia through this state to its Northern frontier, and the towns of Winnsboro, Camden and Cheraw suffered from visitations by fire. If a single town or village or hamlet within their line of march escaped altogether the torch of the invaders, the Committee have not been informed of the exception. The line of General Sherman's march, from his entering the State up to Columbia, and from Columbia to the North Carolina border, was one continuous track of fire.

The devastation and ruin thus inflicted were but the execution of the policy and plan of General Sherman for the subjugation of the Confederate States. Extracts from his public address at Salem, Illinois, in July last, have appeared in the public prints, and thus he announces and vindicates the policy and plan referred to: "We were strung out from Nashville down to Atlanta. Had I then gone on stringing out our forces, what danger would

there not have been of their attacking the little head of the column and crushing it. Therefore, I resolved in a moment to stop the game of guarding their cities, and to destroy their cities. We were determined to produce results, and, now, what were those results? To make every man, woman and child in the South feel that, if they dared to rebel against the flag of their country, they must die or submit." The plan of subjugation adopted by General Sherman was fully comprehended and approved by his army. His officers and men universally justified their acts by declaring that it was "the way to put down the rebellion, by burning and destroying everything."

Before the surrender of our town, the soldiers of General Sherman, officers and privates, declared it was to be destroyed. "It was," deposes a witness, Mrs. Rosa J. Meetze, "the common talk among them, at the village of Lexington, that Columbia was to be burned by General Sherman." At the same place, on the 16ᵗʰ of February, 1865, as deposed to by another witness, Mrs. Francis T. Caughman, "the general officer in command of his cavalry forces, General Kilpatrick, said, in reference to Columbia: 'Sherman will lay it in ashes for them.'" It was the general impression among all the prisoners we captured," says a Confederate officer, Captain J.P. Austin of the Ninth Kentucky Reg. Cavalry, "that Columbia was to be destroyed." On the morning of the same day, February 16ᵗʰ, 1865, some of the forces of General Sherman appeared on the Western side of the river, and, without a demand of surrender, or any previous notice of their purpose, began to shell the town, then filled with women, children and aged persons, and continued to do so at intervals throughout the day.[66]

After a small force of Confederate defenders withdrew from Columbia, the town was formally surrendered. The committee report resumed:

By eleven o'clock A.M. the town was in possession of the Federal forces…They had scarcely marched into the town, however, before they began to break into the stores of the merchants, appropriating the contents or throwing them in the streets and destroying them. As other bodies of troops came in, the pillage grew more general, and soon the sack of the town was universal. Guards were, in general, sent to those of the citizens who applied for them, but in numerous instances they proved to be unable or unwilling to perform the duty assigned them. Scarcely a single household or family escaped altogether from being plundered. The streets of the town were densely filled with thousands of Federal soldiers, drinking, shouting, carousing, and robbing the

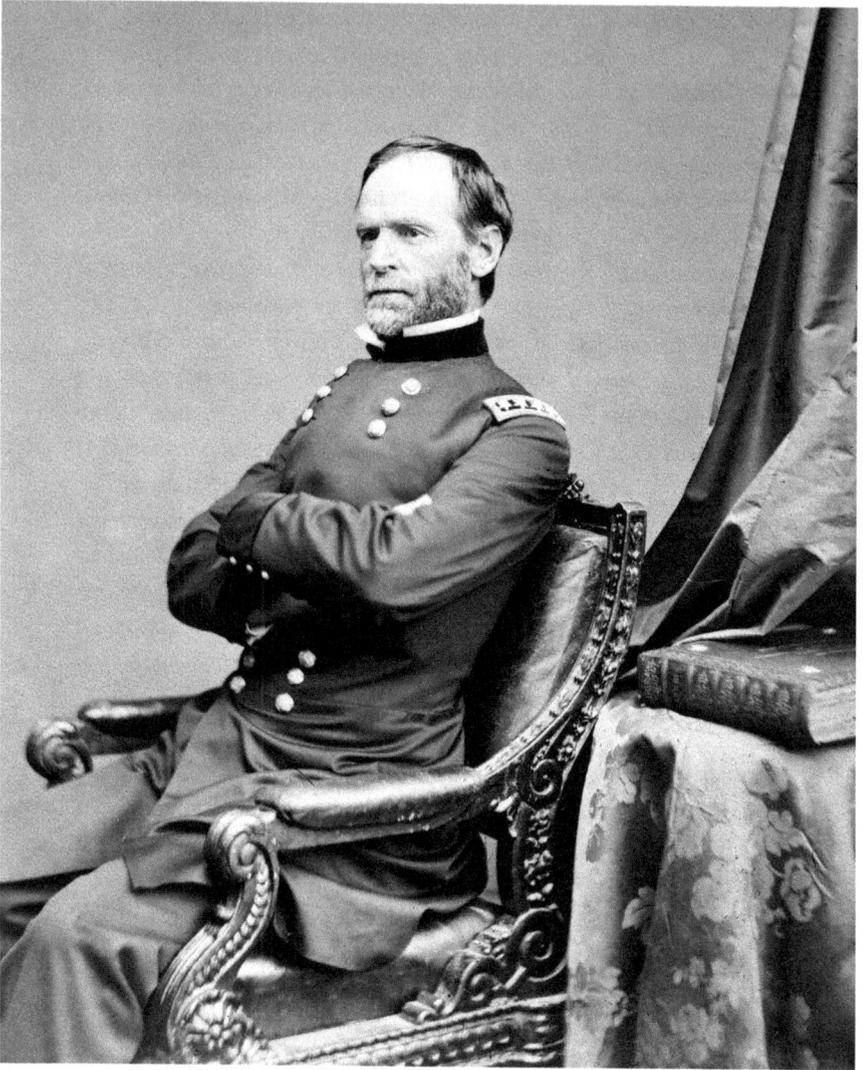

General William Tecumseh Sherman (1820–1891). *Library of Congress.*

defenceless inhabitants, without reprimand or check from their officers;
and this state of things continued until night.[67]

About sundown, General Sherman, who was in the company of the
mayor, told him to go home and "rest assured that your city will be as safe in
my hands as if you had controlled it."

He added, that he was "compelled to burn some of the public buildings, and in doing so did not wish to destroy one particle of private property." "This evening," he said, "was too windy to do anything." An esteemed clergyman, Rev. A. Toomer Porter, testifies that the same afternoon, between six and seven o'clock, General Sherman said to him: "You must know a great many ladies—go around and tell them to go to bed quietly; they will not be disturbed any more than if my army was one hundred miles off." He seemed oblivious of the fact that we had been pillaged and insulted the whole day. In one hour's time the city was in flames.

Meanwhile the soldiers of General Sherman had burned, that afternoon, many houses in the environs of the town, including the dwelling of General Hampton, with that of his sisters, formerly the residence of their father, and once the seat of genial and princely hospitality. Throughout the day, after they had marched into the town, the soldiers of General Sherman gave distinct and frequent notice to the citizens of the impending calamity, usually in the form of fierce and direct threats, but occasionally as if in kindly forewarning...One of our citizens, of great intelligence and respectability, William H. Orchard, was visited about seven P.M., by a squad of some six or seven soldiers, to whose depredations he submitted with a composure that seemed to impress their leader. Of his conversation with this person, the gentleman referred to testifies as follows: "On leaving the yard he called to me, and said he wished to speak to me alone. He then said to me in an undertone: 'You seem to be a clever sort of man, and have a large family, so I will give you some advice: if you have anything you wish to save, take care of it at once, for before morning this d—d town will be in ashes—every house in it.' My only reply was: can that be true? He said, 'Yes, and, if you do not believe me, you will be the sufferer; if you watch, you will see three rockets go up soon, and if you do not take my advice, you will see h-ll.'" Within an hour afterwards, three rockets were seen to ascend from a point in front of the Mayor's dwelling. But a few minutes elapsed before fires, in swift succession, broke out, and at intervals so distant that they could not have been communicated from the one to the other. At various parts of the town, the soldiers of General Sherman, at the appearance of the rockets, declared that they were the appointed signal for a general conflagration. The fire companies, with their engines, promptly repaired to the scene of the fires, and endeavored to arrest them, but in vain. The soldiers of General Sherman, with bayonets and axes, pierced and cut the hose, disabled the engines, and prevented the citizens from extinguishing the flames. The wind was high and blew from the West. The fires spread and advanced with fearful rapidity, and soon enveloped the heart of the town. The pillage, begun upon the entrance of the hostile forces, continued

without cessation or abatement, and now the town was delivered up to the accumulated horrors of sack and conflagration. The inhabitants were subjected to personal indignities and outrages. A witness, Captain W.B. Stanley, testifies that, several times during the night, he saw the soldiers of General Sherman take from females bundles of clothing and provisions, open them, appropriate what they wanted, and throw the remainder into the flames. Men were violently seized, and threatened with the halter or the pistol to compel them to disclose where their gold or silver was concealed.

The revered and beloved pastor of one of our churches, Rev. P.J. Shand, states that, in the midst and during the progress of the appalling calamity, above all other noises, might be heard the demoniac and gladsome shouts of the soldiery. Driven from his home by the flames, with the aid of a servant he was bearing off a trunk containing the communion plate of his church, his wife walking by his side, when he was surrounded by five of the soldiers, who requested him to put down the trunk and inform them of its contents—which was done. The sequel he thus narrates: "They then demanded the key, but, I not having it, they proceeded in efforts to break the lock. While four of them were thus engaged, the fifth seized me with his left hand by the collar, and, presenting a pistol to my breast with his right, he demanded of me my watch. I had it not about me, but he searched my pockets thoroughly, and then joined his comrades, who, finding it impracticable to force open the lock, took up the trunk and carried it away. These men," he adds, "were perfectly sober."[68]

Speaking to a citizen of Columbia that night, General Sherman blamed the burning of the city on the liquor his soldiers had found in it. "Your Governor is responsible for this," he told the citizen. The general asserted that the governor ought to have destroyed all the liquor and that because he did not, "my men have got drunk, and have got beyond my control, and this is the result."[69] The committee report, however, noted the discipline of the troops, observing that when General Sherman ordered his soldiers out of Columbia, the city was cleared within an hour and a half:

From that time until the departure of General Sherman from Columbia (with perhaps one or two exceptions), not another dwelling in it was burned by his soldiers, and, during the succeeding days and nights of his occupation, perfect tranquility prevailed throughout the town. The discipline of his troops was perfect, the soldiers standing in great awe of their officers.

That Columbia was burned by the soldiers of General Sherman, that the vast majority of the incendiaries were sober, that for hours they were

seen with combustibles firing house after house, without any affectation of concealment, and without the slightest check from their officers, is established by proof, full to repletion, and wearisome in its very superfluity. After the destruction of the town, his officers and men openly approved of its burning, and exulted in it. "I saw," deposes the Mayor, "very few drunken soldiers that night; many who appeared to sympathize with our people told me that the fate and doom of Columbia had been common talk around their camp-fires ever since they left Savannah."[70]

Before the city's surrender, some cotton bales had been placed in the middle of the wide streets of the city "in order to be burned to prevent their falling into the possession of the invaders."[71] But the Confederate commanders, including General Wade Hampton, were afraid this might endanger the town and issued explicit orders that the cotton should not be burned. The Confederate forces withdrew from Columbia, leaving the cotton in the streets. Later on, after attributing the burning of the city to his drunken troops, General Sherman claimed that General Wade Hampton was responsible for the city's destruction and that his men had set the cotton on fire before departing. Sherman later admitted that this was a lie he had invented to shake the confidence of the South Carolina people in General Hampton.

The committee report offered the deposition of Confederate general M.C. Butler, who was "personally present with the rear guard of his division," and stated that "General Wade Hampton withdrew, simultaneously with him…and that General Hampton, on the morning of the evacuation, and the day previous, directed that the cotton must not be set on

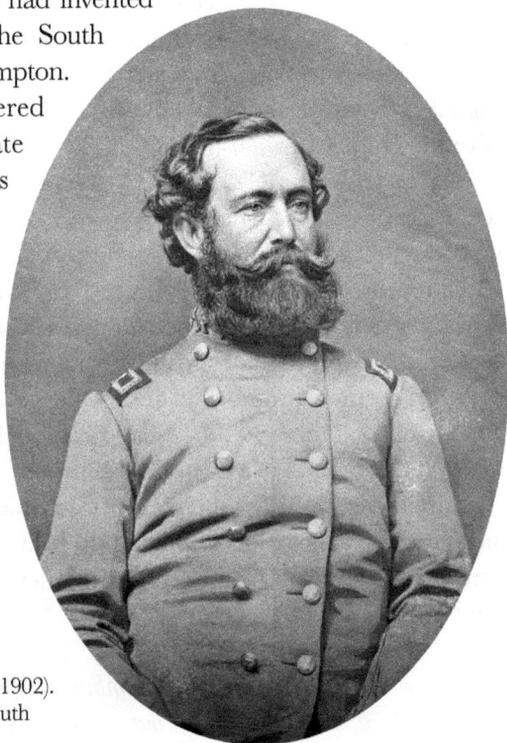

General Wade Hampton, CSA (1818–1902). Hampton was later the governor of South Carolina. *Library of Congress.*

fire; and this order…was communicated to the entire division, and strictly observed."[72] The report added:

> *A clergyman highly esteemed at the North, as well as at the South, Rev. A. Toomer Porter, thus testifies: "General Hampton had told me at daylight, in answer to the question whether he was going to burn the cotton, 'No, the wind is too high; it might catch something, and give Sherman an excuse to burn this town.'"*[73]

Numerous accounts by the citizens of Columbia have survived in contemporary letters and other documents corroborating the narrative of the committee report. For example, in a letter dated February 24, 1865, written by Harriott Horry Ravenel, she described how a "roaring stream of drunkards" poured into her house, "plundering and raging" yet at first "curiously civil and abstaining from personal insult," although they told her that "South Carolina must be destroyed." Later, more Federal soldiers came into her home, ruder and more violent," one of whom took her by the shoulders, swore at her and threatened to burn her house.[74]

Though the original affidavits of more than sixty individuals were lost or deliberately destroyed, excerpts from them remain, and the evidence they offer is summed up in the committee report. Using these sworn statements, the committee members compiled an overall description of the burning of Columbia. One eyewitness who was deposed, Edwin J. Scott, stated that "the universal testimony of our people was that Sherman's troops burned the town" and that he had not met one person who believed otherwise. "If," added Scott, "a transaction that occurred in the presence of forty or fifty thousand people can be successfully falsified, then all human testimony is worthless."[75]

In a recent, exhaustively researched and documented study of Sherman's invasion of South Carolina titled *A Carnival of Destruction*, author Tom Elmore asserted that while Sherman still has his apologists, there is a "plethora of evidence" demonstrating that his soldiers were largely responsible for the burning of Columbia.[76] Other historians, such as Joseph T. Glatthaar, agree that that the Federal troops under Sherman's command burned the city.

Captain George W. Pepper, one of Sherman's officers, recalled a "profane and ferocious" song that was sung by some of the Federal troops as they came into Columbia, clearly indicating their intentions there, and recorded it in his memoir published in 1866:

> *Hail, Columbia, happy land,*
> *If I don't burn you, I'll be d—d!*[77]

Chapter 3

ENGLISH AND IRISH SOUTH CAROLINA CONFEDERATES

HENRY W. FEILDEN: A CONFEDERATE ENGLISHMAN

After serving in the British army in India and China, Henry Wemyss Feilden (1838–1921), the younger son of Sir William H. Feilden, baronet of Feniscowles, resigned his commission and volunteered for the Confederate army. Running the blockade in 1863 to get in, he brought with him a parcel of goods sent to General Thomas J. "Stonewall" Jackson from an admirer in Nassau. He obtained a commission in the Confederate army in Richmond, Virginia, and served on General Beauregard's staff in South Carolina. In October 1864, he married Julia McCord, a young lady from a prominent South Carolina family.

Julia, or Julie, as she was called, was the daughter of influential lawyer and editor David J. McCord of St. Matthew's Parish and Columbia and his first wife, Emmeline Wagner. Julia's stepmother was noted author and intellectual Louisa S. Cheves McCord. Sometime after the first Mrs. McCord's death and Mr. McCord's remarriage in 1840, his surviving children by his first wife went to live with relatives. His youngest daughter, Julia, still an infant, was raised by an aunt, Ann Richardson.

The earliest letter between Captain Feilden and Julia McCord is dated April 20, 1864, and concerns mainly the departure of General Beauregard, who was being replaced as the commander at Charleston by General Samuel Jones. Feilden often expressed his admiration for Beauregard and was sorry

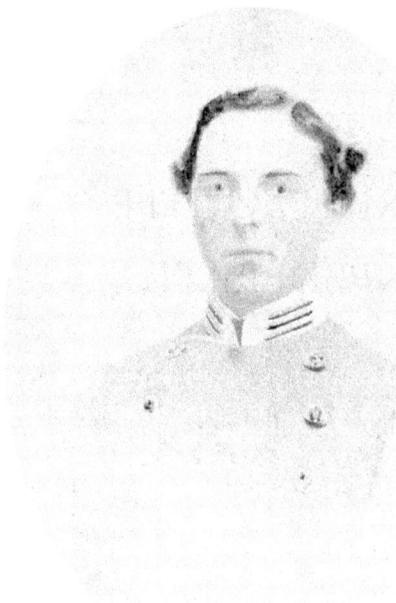

to see him go: "There is not another General in the service as thoughtful as our dear General is. Before leaving he sent for all in the office, privates as well as officers and said goodbye to them. There is no doubt he has got the best military head of any man in this Confederacy and if he only gets a chance he will make his mark on the enemy this spring and summer." In their correspondence there is no hint of where or when Feilden and Julia met, but he addresses her as "darling" in this letter, and the two were almost certainly engaged by then.[78]

At this time in the war, Julia was dividing her time between Savannah, Georgia, and Greenville, South Carolina, where a number of refugees from Charleston had fled for safety. Feilden remained in Charleston as a member of General Jones's staff and was sometimes too busy to write to her as often as he felt that he should have, telling her in a letter of April 20, 1864, "I have only one thing to say and that is you must have no doubts of my love for you darling. You must think me cold and inattentive not writing to you everyday…"[79]

On April 30, 1864, Feilden mentioned that he would try to visit Julia in Savannah, where some of her family lived:

Your nice long letter of the 29ᵗʰ received this evening. I have got through most of my work and now take up my pen to scratch off a few lines to you before going to bed…I am sure dearest you will look very pretty and beautiful to me, any way that you arrange your hair but I expect myself that I should like it best long, however cutting your hair short will do it a great deal of good and make it grow better in future. I will endeavour to come down to Savannah for a day and have an inspection of this new fashioned method of arranging hair. Don't be alarmed about my overworking myself. The business of the office is

already decreasing. The pressure arose from the great number of changes that were made in the troops belonging to this Department. Some are going to Va. some to N. Ca. and others to Tenn., but I expect when that is over we shall have a very quiet summer. The enemy have been shelling Fort Sumter all day both from the land batteries on Morris Island and the Monitors, but the telegraph cable is not working so up to this time we have no news from the Fort. I am waiting up to receive the report. I don't suppose any harm has been done, though I am told the Yankees made the dust and bricks fly in the poor old Fort. I shall answer your letter regularly tomorrow, but the truth is that several of my clerks are sitting writing round me and I don't care for reading your letter when other people are talking around. So you must be content with this scrawl and expect a nice letter from me on Monday.

I heard from Genl Beauregard yesterday. He told me of a lot of things he wanted me to do but said nothing about my rejoining him. Indeed he gave me work to do that will detain me in Charleston even after I have finished my duties with General Jones…

You can hardly understand what a pleasure it is to me receiving your letters. They come at night and I put them on one side until I have waded through all the official letters and written & answered all that require immediate attention, then your letter lies before me and makes me go through my work with redoubled vigour, for I am buoyed up with the thoughts of reading and rereading it before going to bed…As for my ugly photographs, I don't think I care for one of them and you shall have the burning of them all.

I think I can arrange in a short time to get down to Savannah for a day or so. I should much like to hear Bishop Elliott preach, and your idea of my coming on a Saturday and returning on a Monday would suit exactly. Will you give my kind regards to your sister and thank her for me for her kind invitation? I shall not be at all alarmed about coming into a house with seven ladies in it when you are there to take charge of me…And now I must conclude this very unsatisfactory letter darling. There is very little in it and it is hardly worth calling an answer to your long delightful letter which I have only half read and intend taking home to finish before going to sleep. Don't be afraid dearest of my love to you fading. You are so good & kind I am only afraid I don't show my love to you sufficiently, but wait till I go up to Greenville with you and I shall be as attentive to you as you can desire and now my love good-night and believe me to remain your fond

H.W. Feilden
What name have you decided to call me?[280]

The question Feilden asked in his postscript was apparently answered in Julia's next letter, to which he replied: "So you have quite made up your mind to call me Harry. It is a very pretty name, though they always give that name to wild boys in story books. I hope however that I will turn out one of the exceptions that prove the rule."[81]

On May 23, Feilden wrote that he had taken part in a skirmish on James Island:

> Last night I was away down at the front on James Island and only returned this morning dead tired. The enemy landed on James Island yesterday morning, and we had a skirmish with them driving them to their gunboats…
>
> All last night whilst I was sitting out on the ground, I thought of you darling and felt happy to be able to render my small mite in defence of _your_ country. If the Yankees had only come we would have made them suffer terribly…You will trust me dearest won't you to love you ever as I do now, whatever happens. If I am alive you will be protected darling and have some one who will think of nothing else for the rest of his life but making you happy.
>
> I never think of you darling but as my own dear wife, and the knowledge of your love keeps me up altogether. I really am quite hard worked, and almost wish that I could get ill so that I could have an excuse for leaving my office and return with you to Greenville.
>
> I am going to have my will made pet in which I shall leave you everything, for you are the only one in the world that has any claims on me. Don't think me foolish Julie in writing like this but I might get killed someday and if so I should feel as if I was leaving a wife behind in you and it is my duty to attend to your wants.[82]

In his next letter to Julia, he speculated about their future together and waxed affectionate again:

> I really look forward to the war ending this year, and if so and we are spared to one another we shall be able to settle so comfortably in Charleston. I will go into some business and work very hard, and then I shall have you to comfort and inspire me. Then you will be able to amuse yourself with all your old friends and acquaintances, dearest Julie. If I can only make you as perfectly happy as we mortals can expect to be, I shall have no other wish on this earth, and I will always endeavour to repay you for your love and

confidence which you have so kindly and affectionately bestowed upon me.
I do not understand why all these blessings have been given to me. I do not
deserve them and ought to be very grateful to God for it all.[83]

In July 1864, General Samuel Jones recommended that Captain Feilden
be promoted to the rank of major in his department. In a letter to his
commanding general, Jones described him as "an officer of very high order
of merit" who performed his duties "with good judgment, intelligently and
promptly and with untiring attention night and day."[84] That same month,
Feilden anticipated a trip to Greenville to see his fiancée and commented on
reports of "atrocities" committed by the enemy in Virginia:

You are very kind dearest thinking of me day and night. You can have no
idea how it lightens a man's work to think that there is one who loves him
truly and dearly. It is such a comfort Julia to know that I am really and
truly loved. How much I shall have to tell you when I get to Greenville...I
shall write and let you know the day before I leave Charleston.

You have no idea what terrible accounts the Virginia gentlemen have
received in their late letters relative to the atrocities of the raiders in that
state, burning and desolating houses, committing terrible outrages on
women and children, tearing the clothes and jewelry from their persons, and
committing every sort of villainy. Dearest you ought to be thankful that up
to this time this State has been spared these terrible wrongs. I would rather
die a hundred deaths than you should run the risk of such things. We are
not suffering down here as the Virginians are. In fact we know nothing in
S. Ca. of the horrors of war.[85]

In August and September 1864, Feilden, still a captain, was sent to Florida
on what he described as "an inspecting tour." Later, on October 27, he and
Julia McCord were married in Greenville. Afterward, Feilden had to return
to his duties in Charleston.

On December 21, 1864, in his first letter to his new wife, Feilden wrote:

My darling wife I write to you a few lines to tell you that I am one of the
most miserable creatures in the Confederacy without you dearest. I have been
completely lost without you all day...My darling you must not get unhappy
or dispirited on my account. You may depend upon it that I shall do my
utmost to take care of myself for your sake, so do try and make yourself as
easy as circumstances will permit.

*I am so low spirited tonight that I can hardly write to you…How I miss
you dearest and all your kindnesses and attentions. I am nearly distracted at
your going, but it was the right thing to do under the circumstances, for we
shall soon have to undertake active operations.*

*You must try and make yourself as comfortable as you can at Greenville
and write to me for whatever you want and don't spare your money in
getting anything to make you more comfortable…One thing you may be sure
of and that is you have to be looked after, and I will resign my commission
sooner than not to be able to do so.*

*When you get to Greenville give my kind love to all, and remembrances
to friends. I am not writing tonight one tithe of what I should like to tell
you my own precious wife. Leaving you is a great blow to me. I suffer just
as much as you do darling…*[86]

In the first week of 1865, Feilden was still in Charleston and still missing
his bride very much. On January 5, he wrote to her:

*Today I took a walk as far as Legare St., picked a few violets and put
them in my room to remind me of your dear self. A bachelor thinks he has
plenty of friends and in consequence goes through the world in a free and
easy selfish sort of manner, but the man who knows and appreciates a
true woman's love, as I do yours, can never be contented away from her.
Everything else in this world appears cold, selfish, hollow and insincere.*[87]

In an earlier letter, Captain Feilden had expressed his thankfulness that
South Carolina had been spared "the horrors of war," but in early 1865,
the state would see its share of them when General Sherman began his
destructive march across the state. It was feared that he would attack
Charleston with his large army of over sixty thousand troops, and in February
1865, the city was evacuated. Feilden left Charleston with Confederate
troops under the command of General Hardee, and when Sherman's armies
reached the Upstate and North Carolina, the Englishman participated in
fierce skirmishing and fighting in those areas. In late February, he wrote to
his wife from Florence, South Carolina:

*We evacuated Charleston on Saturday morning the 18th. Columbia was
occupied by the enemy on the 17th and the enemy left it on the 20th. I have
just seen a gentleman from there. He tells me Columbia is burnt to the
ground and that it is an awful scene of desolation, the population starving.*

Sherman then moved to Camden, burning a large portion of that town. His army is now moving on Cheraw…I have been working night and day since I left Charleston, and have never taken off my clothes. I am wearing the same clothes that I left in. So you see I am a very fair specimen of a Confederate officer. I am very well and in excellent spirits. I hope you are the same. I am distressed of course at the amount of misery that I see around me. I am staggered when I think how God can permit such villains as these Yankees to wander over the country, burn our cities and turn out our women and children to perish of starvation.[88]

In mid-March, Feilden wrote again of Sherman:

I do hope the Yankees will not come to Greenville. If they do you may make up your mind to lose everything. All the reports I have from the rear of Sherman's army agree in saying that he leaves a howling wilderness behind him…This army of Sherman's is more atrocious than anything I have heard of in this war, except Sheridan in the valley of Virginia.[89]

After the war, Feilden returned to England with his wife and was reinstated in the British army. Later, as the naturalist on Sir George Nares's Polar Expedition of 1875–76, he documented the geology of three hundred miles of the coast of Smith Sound, an arctic sea passage, and made extensive and valuable zoological observations and collections. He was a fellow of the Royal Geographical Society, the Zoological Society of London and other learned societies.

In England, the Feildens lived at Wells-Next-the-Sea in Norfolk County and later made their home in Burwash, Sussex. In 1914, they celebrated their golden wedding anniversary. They were to share another six years together before Julia passed away in 1920, leaving a shaken and grieving husband. In a letter to John Bennett of Charleston penned shortly after her death, Feilden wrote, "The death of my beloved wife, your wife's Aunt, and my companion in joys and sorrows for 56 years has given me a bad shake, and I was in bed for ten days after the funeral, but am now allowed downstairs."[90]

Feilden did not live long after losing his dear Julie. He died the following year at the age of eighty-two. In one of his last letters, Feilden expressed his thankfulness for many years of health and happiness he had enjoyed and added that few men had led a happier life or had better friends. His close friend, the famous novelist and poet Rudyard Kipling, called him "the gentlest, gallantest English gentleman who ever walked."[91]

Rudyard Kipling (1865–1936), one of Great Britain's most famous authors. In 1907, he was awarded the Nobel Prize in Literature. *Library of Congress.*

In his autobiography, Kipling expressed his admiration and affection for Feilden, whom he compared to Colonel Newcome, a highly virtuous, lovable character created by the English author William Makepeace Thackeray, writing, "I was honoured till he died by the friendship of a Colonel Wemyss Feilden…He was in soul and spirit Colonel Newcome, in manner as diffident and retiring as an old maid…and up to his eighty-second year could fairly walk me off my feet, and pull down pheasants from high heaven…Mrs. Feilden at seventy-five was in herself fair explanation of all the steps he had taken—and forfeited."[92]

In his unpublished memoirs of the war, Feilden recounts an episode of 1865 just after the surrender, when he was in Orangeburg trying to earn some money by transporting inland cotton in wagons he owned. A Northern

speculator who was anxious to get to Augusta, Georgia, for an important business deal offered him $100 to take him there. Feilden recalled that, during their journey in his mule-drawn buggy, the man took him "for a 'cracker,' told me many yarns, some rather embroidered, so I put him right."

The Northerner asked him, "How do you know all this?" and Feilden told him, "From reading."

Surprised, the speculator said, "You are the most intelligent young 'mule-whacker' I ever expected to meet down South. Are you all like that?"

Feilden replied, "Yes, but most of them are a good deal more."

"Great Scott," the man exclaimed, "I never thought it!"[93]

FOR WEAL OR WOE: CHARLESTON'S WARTIME BRITISH CONSUL

Just after South Carolina seceded in December 1860, a Charleston resident of English birth wrote to a relative in England to exult in the state's independence and the dissolution of the union:

> *The glorious union! The model republic is at an end. The people of the North, for fifty years past, have amused themselves at the expense of the Southerners. They have sneered at them and traduced them without measure, and while they have grown rich and over-insolent they have been feeding upon Southern industry, and all their prosperity is traceable to Southern industry and products. Millions upon millions have the South unjustly paid under the Northern protective tariff system. With secession, this tribute payment ceases. There is no wonder that the Northerners are union men, and denounce the impropriety of secession. It occasions them pecuniary loss.*[94]

The letter writer was Henry Pinckney Walker, and as his name might suggest, he had ties of blood as well as strong political sympathies with South Carolina. Born in 1817 (some sources say 1816) in Pulham St. Mary, a village located in the English county of Norfolk, he was the son of Reverend Henry Walker and his wife, Jane Douglas Pinckney, the latter a native of South Carolina. She was the daughter of Hopson Pinckney, who owned Cypress Pond Plantation in St. Thomas and St. Denis Parish, South Carolina. Henry Pinckney Walker studied law in England, but eventually, in 1839, he departed

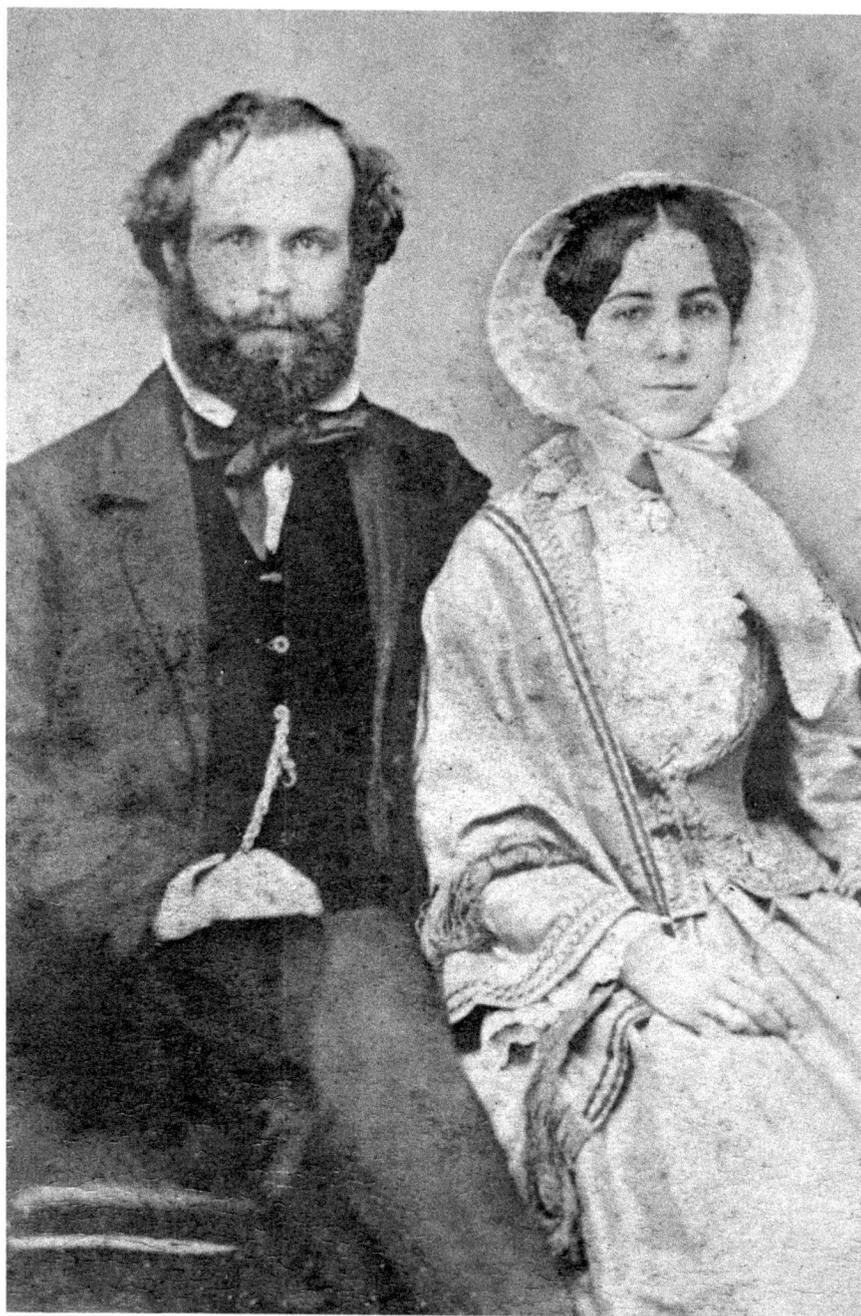

A circa 1860 carte-de-visite photograph of Henry Pinckney Walker and his wife, Dora, taken in Charleston. *From the collections of the South Carolina Historical Society.*

his country and took up residence in Charleston, where he was admitted to the South Carolina Bar in 1841 and later entered the British consular service. In 1841, he also married his English fiancée, Dorothy Modd Box, and both husband and wife became United States citizens.

Walker was the acting British consul in Charleston during the later half of the 1850s and was appointed vice-consul on May 12, 1860, and again served as the acting consul from 1863 until August 12, 1865, when he was appointed consul for the states of North and South Carolina.

Letters found in the Henry Pinckney Walker papers dating from about 1840 into the 1880s offer an intriguing narrative of the Walker family's life and thoughts, and those penned during the 1860s are especially interesting. In the same letter quoted above, which Walker wrote to his sister Nelly in January 1861, he regretted the fact that Europeans were getting their news of America from only Northern newspapers, and he maintained that they were being "grossly misled":

> *When I was in England 10 years ago, I was commissioned by the editor of the* Charleston Mercury *to negotiate for an exchange with editors of London papers. The answer I got was "We have no need of Charleston papers…" And so they have gone on to the present time…We find it very hard to read a Northern paper without a smile on account of the very preposterous lies they circulate, and the London press generally reprints them all.*
>
> *Hardly a week has transpired this winter but what something has been shown by the New York press to have been committed by a Southern mob or a Charleston mob…As to such a thing as a mob I have seen such things in England, and I have often read accounts of them and their doings in the northern cities and Canada. But upon my soul, I have never seen the first germ of one in Charleston, the most peaceful, conservative, order-loving place in creation.*[95]

Walker's characterization of conditions in Charleston is corroborated by another Charlestonian, Reverend Thomas Smyth, who, in a letter of January 14, 1861, wrote to a Northern journalist protesting false reports in Northern papers: "I never saw greater order, quietness, confidence and peace—no mobs nor gatherings nor tumult; nor even an illumination for Secession. None of the occurrences pathetically and patriotically related have occurred. No levies have been made by private marauders."[96]

Despite the fact that Northern newspapers were providing reports for the European news outlets, many Englishmen, like Walker, were sympathetic to

the Southern cause, and some felt that the North had no just reason for its invasion of the South. In an article titled "American Crisis" that appeared in an 1861 issue of the *London Quarterly Review*, the writer observed, "It does seem the most monstrous of anomalies that a government founded on the 'sacred right of insurrection' should pretend to treat as traitors and rebels six or seven million people who withdrew from the Union, and merely asked to be left alone."[97] London's *Cornhill Magazine* asked at the same period, "With what pretence of fairness, it is said, can you Americans object to the secession of the Southern States when your nation was founded on secession from the British Empire?"[98]

In a letter written to a friend in 1862, no less a personage than Charles Dickens opined that in America, slavery had nothing to do with the "American quarrel" as far as the morality of that institution was concerned. The North, he asserted, had become more powerful than the South through having taxed that region "most abominably" and feared that unless slavery could be restricted in the West, the South would recover its old political power. It was for the preservation of its own political power, and not because of any "chivalrous sentiment," that slavery was opposed by the North. "Every reasonable creature may know," Dickens added, "if willing, that the North hates the Negro, and that until it was convenient to make a pretence that sympathy with him was the cause of the War, it hated the abolitionists and derided them up hill and down dale." Dickens also wrote that it was "distinctly proveable" that secession was not rebellion.[99]

In May 1862, Walker's wife, Dorothy (called Dora), wrote to Nelly in England. Dora described the momentous events of the previous year, as well as the family's present

Charles Dickens (1812–1870), an internationally famous and beloved Victorian author and social critic. *Library of Congress.*

difficulties, including their concerns for two sons who had enlisted in military service. However, she urged her, "Do not be anxious about us."

We are very brave, wonderfully so, for we have many privations to endure and are already suffering for the want of things which we have idly allowed the North to provide while we could easily supply ourselves...Everything is enormously dear and I find it very hard to get along. Pinck takes it very bravely and seems to have made up his mind to want...But having warmly espoused the Southern Cause will not run away to England and escape the danger. We have been crushed down under the heel of the North and allowed her insolently to hold us in subjection, but now like one man the Cotton States have arisen & whether for weal or woe cling together against a foe who has misrepresented the South in every country in Europe...

The boys joined a volunteer company, "The Palmetto Guard," and when Anderson ran away frightened from Fort Moultrie to Fort Sumter after spiking the guns at Fort Moultrie and burning all he could, though nobody dreamed of troubling an officer who in holding the fort, was only fulfilling his duty to his government, they determined to offer themselves for any duty. After sending a message to our Govt. that Fort Sumter should not be reinforced or provisioned provided we left Anderson alone, Lincoln sent the Star of the West *steamer with arms, provisions & troops to our harbor arranged to arrive at night. Of course getting wind of intention we turned her back & from that hour distrusted every protestation of Lincoln's government and all Seward's peace lies, and prepared in earnest for the worst. Meanwhile Army officers in service resigned and joined the Southern Confederacy, and if the North outnumbers us by millions our army is commanded by the very flower of the U.S. officers. Our last is Maury who has distinguished himself the world over by his scientific discoveries & theory of the winds.*[100]

We were very quietly awaiting the promised evacuation of Fort Sumter when we suddenly got a telegraph dispatch that 7 vessels of war have left for the South to reinforce Fort Sumter with men & provisions, peaceably if possible, by the force of arms if need be...The next day General Beauregard gave Anderson notice to quit & he refusing & we hourly looking for the fleet, at 20 minutes past 4 A.M. firing commenced. In consequence of a gale at sea only four out of the seven vessels reached the Bar, and Nelly, Sophy & I stood the live long day seeing the bombardment from a beautiful Battery that runs along one side of our harbor. The shells like balls of snow we saw fall into Fort Sumter, and with a glass I could see the cannon balls

from Fort Sumter whizzing thro the air. I cannot describe the two days of awful anxiety we spent. Harry was serving a gun in the iron battery. Charlie was at a rifled cannon sent from England by a Charleston merchant as a presentation to his native state (he lives in Liverpool). Strange to say that cannon did the most efficient service and it only arrived on Morris Island the night before the fight, the ship that brought it having made the quickest passage from Liverpool it had ever made. The Palmetto Guard volunteered to mount it that same night and did so not knowing at the time that the fight was to be the next day. When the first boat came up saying that up to that time nobody was killed, no one dared believe the news as it seemed impossible. By that time we could discern the Ships of war off the Bar and of course expected them to join in the fight every instant. But strange to say even when Fort Sumter took fire they never attempted to assist Anderson, who sadly needed help. There they lay, their steam up, plenty of surf boats, plenty of water on the Bar for them to have run the Gauntlet of our Batteries but they never moved. They saw the flames roaring round the fort and finally their own flag shot away by our guns, after Anderson had shown them signals of distress 3 times...

We have been working indefatigably for the troops. Shirts, drawers, knapsacks, etc. And the chivalrous enthusiasm of the people knows no bounds. Young men brought up in the very lap of luxury join everyday as privates, and the hardest labour has been done by the whitest hands. Gentlemen who have magnificent homes and servants at every door, leave wife and children and go to the war...

Our President, Jeff Davis, would delight you. He is a most perfect gentleman, quiet and very dignified, and a most brave officer all through the Mexican War...[101]

In February 1863, Dora wrote to other relations in England about conditions in Charleston and her "soldier boys":

Pinckney (you by this time know) is Acting Consul...so we quietly stay expecting to remain till the shot and shell fall over our poor doomed City...I had so hoped that some fortunate turn in the wheel of fortune might have saved our city from the Yankee vengeance but now alas! we can only leave its fate to the mercy of a gracious Providence who has never yet allowed the enemy to leave our shore unscathed. In every attempt at a landing near the city we have gloriously driven them back to their gun boats...Blockaded as we are and not accustomed to manufacture for ourselves, do not fancy we

are all shaking and trembling and weeping. Oh! no! there is a calmness, a quietude, a stillness perfectly astonishing as if each and every soul had his or her part to play in the drama and looked forward to suffering and even death with the sternness of determination and resignation. I never dreamed of living to see heroism, "self sacrifice," and intense love of country so commonly evident as here, and if women could be angels on earth certainly some of our women deserve the name...Both my soldier boys have been ill in consequence of exposure at the taking of the I.P. Smith gunboat but are well again. Charlie is to assist his father in the Consulate...General Ripley has given him a furlough till he is required for active service...[102]

"Charlie" was Charles Edward Walker, the eldest son. He and his brother Harry (Henry Pinckney Walker Jr.), who was born in 1845, were members of a field artillery company that formed part of Manigault's Battalion, also known as the Siege Train. In late 1863, George Rivers Walker, one of the younger boys approaching the age of military service, was sent to England to live with relatives there and attend school. On September 20, 1863, his father wrote to the boy's aunt Nelly to inform her that George had left for Wilmington, North Carolina, where he was to take passage on the blockade runner *Elizabeth* for Nassau and from there to sail to Liverpool.

On August 22, 1863, Federal forces at Morris Island began the artillery bombardment of Charleston. On August 21, 1863, their commander, General Quincy Gillmore, had sent a letter to General Beauregard, the Confederate commander at Charleston, demanding the "immediate evacuation of Morris Island and Fort Sumter."[103] Gillmore stated that if this demand were refused, he would "open fire on the city of Charleston from batteries already established within easy and effective range of the heart of the city."[104] Fitzgerald Ross, a foreign newspaper correspondent in Charleston at the time, wrote of Gillmore (misspelling his name):

Next morning we heard of the "fair warning" General Gilmore had given of his intention to shell the city. It seems that at nine o'clock in the evening a note had been sent to the commanding officer at Fort Wagner to forward to General Beauregard, in which it was demanded that Fort Wagner, Fort Sumter, and the other defences of the harbour, should be immediately given up to the Yankees; if not, the city would be shelled. Four hours were graciously given to General Beauregard to make up his mind, and to remove women and children to a place of safety. The note was entirely anonymous, no one having taken the trouble to sign it. It reached General

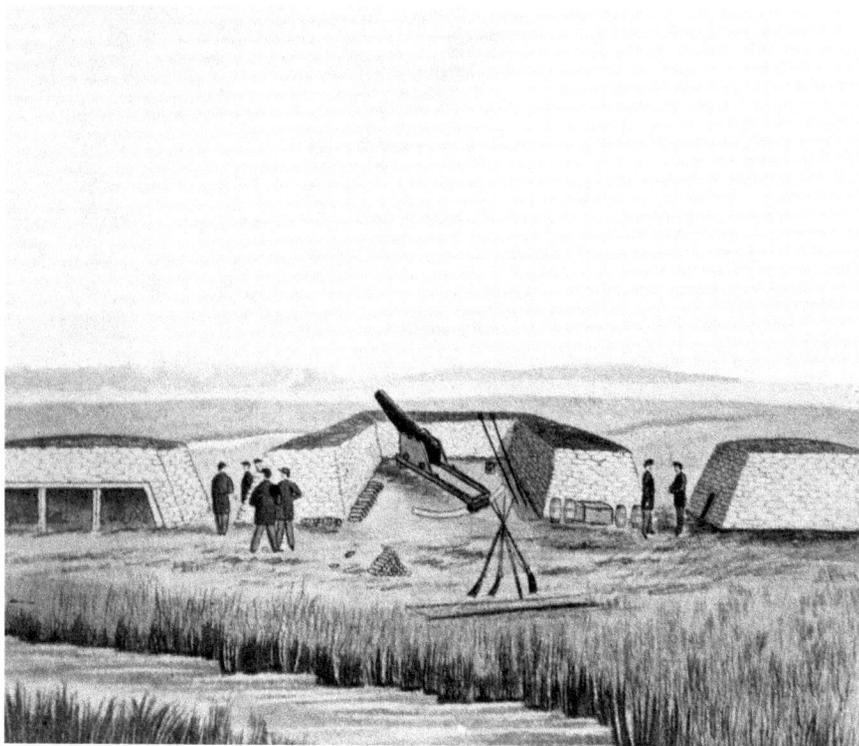

This drawing shows Federal soldiers and a Parrott cannon named the Swamp Angel positioned near Morris Island. This gun and others like it shelled the city of Charleston in what became the longest siege in modern military history up to that time. *Library of Congress.*

Beauregard about midnight, and was of course returned for signature and without an answer. At half past-one the shelling commenced. No doubt General Gilmore wished that the effects of the bombardment should have their influence on General Beauregard before it was possible that he should give an answer to the summons...

It is rather an extraordinary proceeding, to say the least of it, to bombard the city because the harbour defences, which are three and four miles distant, cannot be taken; and the attempt to destroy it by Greek fire is very abominable; but the spite of the Yankees against Charleston, "the hotbed of the rebellion," is so intense that they would do anything to gratify it.[105]

Due to the bombardment of the city, the Walker family took refuge at Belvedere, a plantation on Charleston Neck owned by their relations the Shubricks. In 1863, lamenting the departure of her son George, as well as

the absence of other children, Dora Walker wrote of the place in a letter to her sister Ellen:

We are still in the country where George left us and we do not suppose there is any chance of our ever returning to our own house as the Greek fire shells sent here by Lincoln will consume what their guns fail to destroy. The place we are at is one of the most beautiful on the river. The avenues of noble oaks arching over long roads and the glorious sweep to the splendid river blue…as you never see water in Europe. Would make me as happy as a queen but for the absence of my precious children four are now away, dear little Carrie her godmother would not give her to me when she ran away from the doomed city and has carried her into the upper part of the state…[106]

As the war wore on, a letter that Mrs. Walker penned to her son George in England in the summer of 1864 revealed the family's increasing discouragement and hardships:

You speak of coming to America as something to be desired, believe me my dear child except for the separation which is very painful to me, I do not desire you to return, this is a changed country. War has brought forth passions of the worst sort and this is no longer the Charleston of olden times. We are suffering from another severe bombardment, Fort Sumter holds out a mass of ruin, but her bomb proofs still secure. We have been for the past week indefatigably nursing one of the Citadel boys, Lawrence Fishburne, who was taken ill, his mother away…Charlie has been again very ill with country fever and is now over on a frolic to Columbia for a change, their company situated in a very unhealthy region and every day I expect to hear of Harry being sick…How I wish your father had never left England. His spirits are a great deal better than when you left, he is more resigned to the sadly monotonous life for we know nothing of what goes on in the world. No new books but an unending anxiety about something to eat…The Yankees appear to be running riot thro Georgia…numbers of the Charleston dragoons have been killed and I see no prospect of a termination of the war…[107]

Discouragement and frustration were also evident in a letter to Nelly from Henry Pinckney Walker dated June 9, 1864, in which he described himself as being in the grip of "a despondency I cannot shake off":

There goes a shell. When will this state of things stop. Are not the Yankees nauseated with slaughter or will they ever be so. Surely the thousands upon thousand of them that have been lately killed in Virginia unburied and decomposing are enough to sicken the most brutal of savages. How long will more people present themselves to be duped and slaughtered by the unprincipled men who govern them? Verily the battle is not always to the strong. But I am sick of war and its incidents and should deem myself in Paradise if I could be free of all the horrid thoughts and anxieties which this war keeps constantly present to one's mind.[108]

While his family resided safely out of the range of the shelling, Henry Pinckney Walker risked spending time in Charleston, where he observed the effects of the continued bombardment of the city and even experienced a close call one day when a shell fell within eight yards of him. On September 2, 1864, he wrote about it to Nelly:

The Humanitarians on Morris Island have lately treated us to a new specimen of projectiles. They are very liberally supplying us with shells with both time and percussion fuses, so that those which do not burst in the air, explode as soon as they strike the earth. They extend much farther into the City than formerly...fragments have reached St. Pauls Church, and the day before yesterday a fragment struck the curb stone in front of Mrs. Rees home. I was about 25 feet from it. This morning a cow was killed on the Citadel green...As the fire drops from the shell that explodes in the air, it not infrequently sets fire to the building on which it falls, many of the houses being covered with split cypress wood called shingles instead of slate, and when the shingles are old & dry if there is any wind they readily take fire. At the present time there is a furious fire going on in Ward No. 1 and as a matter of course a furious shelling, for the Humanitarians select such opportunities for the projection of their infernal machines with especial vigour.[109]

In February 1865, when it was feared that the massive army under the command of General William T. Sherman would descend on Charleston, the city was evacuated, but the Walker family apparently remained in the area. Dora reported to her sister Ellen on March 13: "Should we remain at the South I fear we may yet suffer much as the whole country is desolated...Pinck looks worn and old. His duties have been perfectly overwhelming, his office thronged from early morning with [British] subjects each with his story or wanting advice..."[110]

Not long after this letter was written, just one month before the war's end, the Walker family must have received word of the fate of their son Harry. Henry Pinckney Walker Jr. died on March 12, 1865, near Fayetteville, North Carolina, where Confederate forces had retreated during their last desperate struggles against General Sherman's army. On that same date, a fellow Englishman and Confederate soldier, Captain Henry W. Feilden, wrote to his wife and described the arduous days preceding young Walker's death:

> *As for our doings as an army I have not much to tell you except that we have been running from Sherman ever since we left Charleston and will continue to do so until we can join with Bragg & Beauregard then I suppose we shall turn and give fight.*
>
> *We were driven out of Cheraw on the 3rd by the enemy. We had a little skirmish there as we were burning the bridge behind us. Ned Parker had his mare killed under him there; 6 shots put through her.*
>
> *We then retreated to Fayetteville pursued by the enemy, and got there on the 10th and evacuated it yesterday morning fighting the Yankees down the streets as our forces retired.*[111]

Captain Feilden's next letter to his wife reported, "One of Mr. Pinckney Walker's sons died this morning on the line of march of congestion of the brain."[112]

When the war began in 1861, Walker renounced his U.S. citizenship, and though he and his wife remained in South Carolina after the war's end, he did not seek to become a citizen again. For a period in the 1880s, Mr. and Mrs. Walker lived with their son George at his house on Hibben Street in Mount Pleasant, and in Petrona Royall McIver's history of Mount Pleasant, she notes that while residing there, Henry Pinckney Walker was "credited with having introduced...the yellow English primrose called locally the buttercup."[113] Later in the same decade, the Walkers owned a home in Summerville, South Carolina.

On August 24, 1890, Henry Pinckney Walker died in New York City, where he had gone seeking medical treatment for serious health problems. An obituary that appeared in the Charleston papers paid him the following tribute:

> *He was a man of fine education, both in his profession and polite literature. He never lost his individuality as an Englishman. He was a thorough gentleman in every way of life, and a most interesting talker on all current*

subjects. His death will be regretted by thousands of friends in Charleston, who he attached to himself in a long, prosperous and honorable career as lawyer and consul.[114]

CAPTAIN JOHN C. MITCHEL: AN IRISH CONFEDERATE

John C. Mitchel was born in Ireland in 1838. His father, John Mitchel (1815–1875), was a famous Irish nationalist who was convicted of treason by the British in 1848 and transported first to Bermuda and then to a penal colony in Australia, from which he escaped in 1853. The elder John Mitchel and his family settled in America, and he continued his nationalist activism by founding a radical Irish newspaper in New York, denouncing British policy in his native country and worldwide. Scornful of Victorian ideas of social, scientific and technological progress, he wrote in his famous *Jail Journal*, "It is altogether a new thing in the history of mankind, this triumphant glorification of a current century...no former age, before Christ or after, ever took pride in itself and sneered at the wisdom of its ancestors; and the new phenomenon indicates, I believe, not higher wisdom but deeper stupidity."[115]

John Mitchel admired Southerners, whose agricultural civilization he saw as a haven from modern industrialization. In 1855, his sympathy for the Southern cause took him to Tennessee, where he began another newspaper, the *Southern Citizen*. When the war came, three of his sons enlisted in Confederate service, and two gave their lives in battle. The youngest, Private William Mitchel (born in 1844), received a mortal wound in July 1863 while carrying his regiment's flag in Pickett's charge during the Battle of Gettysburg.

The eldest of John Mitchel's sons, John C. Mitchel, was

This portrait of Captain John C. Mitchel (1838–1864) is taken from *The Defense of Charleston Harbor* by John Johnson, a Confederate engineer at Fort Sumter and later an Episcopal priest. *From the collections of the South Carolina Historical Society.*

commissioned as a lieutenant in the First Regiment of South Carolina Artillery and assigned to Fort Moultrie near Charleston. He was soon promoted to captain and, in January 1863, took part in the capture of the Federal gunboat *Isaac P. Smith*, operating on the Stono River. Later, Captain Mitchel was placed in command of the defense of the southern end of Morris Island (in Charleston Harbor), which was besieged by the combined forces of the U.S. army and navy. Regarded as a promising and distinguished officer, he was recommended for promotion to the rank of major.

On May 4, 1864, Mitchel, still a captain, was put in command of Fort Sumter. In July of that year, during the third great bombardment of the fort, he was mortally wounded by the explosion of a mortar shell while observing the enemy's movements from an earthwork parapet.

In his book *The Defense of Charleston Harbor*, John Johnson wrote of Mitchel's death:

> On the fourteenth day of the bombardment, being the 20th of July, 1864, Captain Mitchel ascended the stairway of the western angle of the gorge, about 1 o'clock P.M., to examine the movements of the fleet and land force of the enemy, preparatory to writing his daily report for transmission to the city by dispatch-boat that night. Arriving at the head of the stairs and passing out upon the level of the original terreplein of the fort, he found the sentinel there at his post well protected by breast-high shelter within the massive parapet of earthwork necessary to secure the safety of the stair-tower beneath it. Stationing himself near the spot, but not within the sentry-box, he rested his arm and glass on the parapet and began his observations. Before him, in the sea-view, were the low hulls of the monitors lying at anchor off Morris Island, the wooden gunboats and blockaders resting also at their appointed stations outside the bar, and farther out, in the offing, a dispatch-boat going North. No movement in the fleet at all that day, except among the tugs and tenders. The sea was smooth, the sky bright, and the sun blazing with midsummer heat. Hot work in the Union batteries of Morris Island close by, their rifle and mortar-shelling keeping their gunners as busy as they could be; hottest time of all at the battered ruin of a fort taking daily transformation into an indestructible earthwork.
>
> The commander was not unduly exposing himself, but while engaged with his glass a mortar-shell of the largest kind rose in the air, and, descending well to the westward of the fort, as if about to strike the wharf, burst at an altitude of some eighty feet above the water. The bursting of a mortar-shell

so high in the air and somewhat outside of the walls was no more to the garrison than a matter of ordinary occurrence, scarcely noticeable in the climate of the fort. The commander continued his observation through it all, his eye fixed to the glass, until suddenly struck to the ground by a large piece of the shell, wounding him with great laceration on the left hip. Had he been in the sentry-box, he would have escaped all hurt, for that was protected on the rear as well as front.

The sentinel at once gave the alarm by calling at the head of the stairs, and was soon joined by one or two from the lower casemates. Lifted from the spot where he fell, pale and much weakened already by the loss of blood, the youthful commander was in perfect possession of his mental faculties and spoke with calmness of the mortal wound. It was a difficult task to bear his body, though of light weight, from the highest point in the fort down to the hospital. The only way was by the dark, narrow, and winding staircase. Tender as the handling could be, the movement yet caused him the acutest pain. When laid on the surgeon's table in the hospital he required to be revived with stimulants. Later, as his suffering increased, anodynes were administered, but no surgery was attempted, as it was seen from the first that his wound would prove fatal.[116]

Captain Mitchel lingered for about four hours in extreme pain, at times delirious. One of his men, Milton M. Leverett, was by his captain's side the whole time and wrote about it to his mother, describing how difficult it was to watch the life of a "fine noble person ebbing away" before his eyes.[117] Just before Mitchel died, one of his fellow officers asked him what could be done for him, and he replied, "Nothing, except to pray for me."[118] His last words, as recorded on his epitaph, were, "I willingly give my life for South Carolina. Oh! that I could have died for Ireland!" The stone coping outlining Captain Mitchel's grave plot in Magnolia Cemetery in Charleston resembles the shape of a parapet of Fort Sumter.

After the war, John Mitchel Sr. was arrested for expressing anti-union sentiments in a newspaper and was confined at Fort Monroe, where one of his fellow prisoners was Confederate president Jefferson Davis. Mitchel claimed the distinction of being the only man ever imprisoned by both the U.S. and British governments, both of which he despised. He returned to Ireland in 1875 and was elected to serve as a member of the British Parliament, representing the County of Tipperary, shortly before his death.

EXTRAORDINARY WOMEN OF CONFEDERATE SOUTH CAROLINA

In 1863, not long after he had run the Federal blockade to enter Charleston, South Carolina, a young Englishman named Henry W. Feilden, newly commissioned as an officer in the Confederate army, wrote to an aunt in England about the women of the South:

> *The more I see of the Southern ladies, the more I hear of their actions, of their grand heroism, of their sacrifices, of their sufferings, the more I am lost in astonishment. Words cannot express my admiration of them—as the President justly styled them in his address—"our incomparable women." The war could not have gone on without them; from the delicate lady to the hardy peasant wife they have all sent without a murmur their husbands, sons and those they hold nearest and dearest to the war. They have tilled the fields, they have clothed the troops, they have nursed them in the hours of sickness, and above all they have prayed unceasingly to the great Ruler of the Universe, to the God of Battles, to fight for them and theirs for liberty and freedom.[119]*

Throughout the war, President Jefferson Davis often publicly praised the women of the Confederacy. In January 1863, he addressed a crowd who had gathered at his house in Richmond, Virginia, concluding his speech with the following words: "One year ago many were depressed and some despondent. Now deep resolve is seen in every eye, an unconquerable spirit nerves every arm. And gentle woman, too—who can estimate the value of

her services in this struggle? With such noble women at home, and such heroic soldiers in the field, we are invincible."[120]

In South Carolina, there were few women whose services to the Confederacy exceeded those of Louisa S. McCord and Mary Amarinthia Snowden. Another extraordinary South Carolina lady, Ann Pamela Cunningham of Laurens District, kept Mount Vernon (the home of George Washington) sacred and neutral ground during the war, helping to preserve it for posterity. These three ladies were some of the "incomparable women" of the Palmetto State.

LOUISA S. McCORD:
ANGEL OF MERCY, WOMAN OF GENIUS

During the war, Mrs. Louisa S. McCord became well known and highly revered in South Carolina for her tireless work on behalf of the Confederate army. She not only nursed the wounded in the military hospital in Columbia, South Carolina, but also devoted herself to feeding and clothing soldiers, serving as the president of both the Soldiers' Relief Association and the Ladies' Clothing Association of that city.

Her house in Columbia was adjacent to the campus of the South Carolina College (now known as the University of South Carolina), where the main Confederate hospital was located. In time, part of Mrs. McCord's home became a hospital ward. It also served as a dining hall that provided food daily for the ambulatory patients. Her plantation, Lang Syne, provided cotton and food

This portrait of Louisa Susanna Cheves McCord appeared in her biographical entry in the *Cyclopaedia of American Literature* in 1855. *From the collections of the South Carolina Historical Society.*

crops for the Confederacy, and she personally funded the uniforms and equipment for the company of soldiers her son led as captain.

Louisa's father, Langdon Cheves (1776–1857), an attorney and planter from the Abbeville District of South Carolina, achieved national eminence as a statesman, jurist and financier. In the first half of the nineteenth century, Langdon Cheves and John C. Calhoun were the two most prominent and influential South Carolinians in the country. Cheves was a U.S. representative and served as Speaker of the House from 1814 until his retirement from Congress in 1815. During his tenure as Speaker, one of his most important accomplishments was to defeat the re-chartering of the Bank of the United States.

A friend of Mrs. McCord, Miss Isabella D. Martin, wrote of her:

> *It had been said of Mrs. McCord in her youth, that she had two grand passions—her father and her State. In her mature life the passion for her father seemed to have descended with concentrated strength upon her son, of whom she speaks in one of her letters as "my glorious boy." And he was worthy of it all—a loyal, gallant, young South Carolinian of his day. Early in the war he was made Captain of the South Carolina Zouaves, afterwards Company H, Hampton Legion.*[121]

This beloved son, Langdon Cheves McCord, died in 1863 as a result of wounds received at the Battle of Second Manassas, leaving behind a young widow, who gave birth to their only child less than two weeks after his death. Mrs. McCord, however, carried on in her labors to aid the men fighting for the Southern cause despite this devastating loss, of which Miss Martin wrote:

> *When at the age of twenty-one his knightly soul was rendered up to God as a sacrifice for his country, it seemed as if the land for which she lived, and the cause for which he died, were made doubly precious to her. Mrs. James Chesnut writes in her journal "Aug. 9ᵗʰ, 1864—spent today with Mrs. McCord in her hospital—she is dedicating her grief for her son—sanctifying it, one might say, by giving her soul and body, her days and nights to the wounded soldiers at the hospital."*[122]

Louisa Susanna Cheves McCord was born in Charleston on December 3, 1810. She was important in her own time as a writer and intellectual but is generally not well known today. Before the war, she was the author

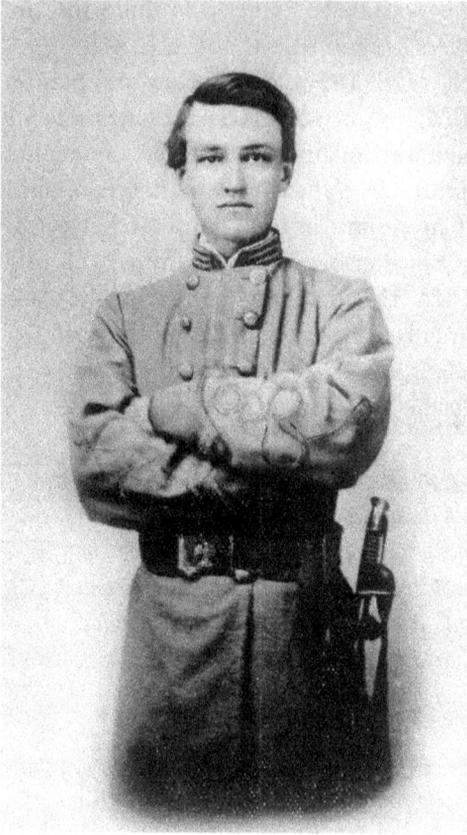

Captain Langdon Cheves McCord died in 1863 from wounds received at the Battle of Second Manassas. His famous mother, Louisa S. McCord, dedicated her 1851 tragedy *Caius Gracchus* to him with a poem that concludes, "God bless thee, boy! and make thee stainless, pure / Upright and true, e'en as my thought doth paint thee." *From the collections of the South Carolina Historical Society.*

of numerous essays on political economy and social issues. Her other writings included poetry, reviews and a blank verse drama titled *Caius Gracchus.* She also translated a book written by Frederic Bastiat, a French political economist, which was published in 1848 as *Sophisms of the Protective Policy.* Although Louisa S. McCord has been written about here and there in the nineteenth and early twentieth centuries, it is only relatively recently that she has begun to receive her due recognition as one of the most significant thinkers of the antebellum South.

Until the age of ten, Louisa received the usual education given to girls of her social class, but when it was discovered that she had an aptitude and passion for mathematics, her father saw to it that she received the same instruction as her brothers. Louisa's cousin William Porcher Miles wrote of her: "Mrs. McCord inherited much of the force and vigor of intellect, and clear logical faculty of her distinguished father…The bent of her genius was rather for matters of state policy and political economy…Now was this strange when we consider the long public life of her father during which she was habitually thrown with the leading statesmen of the country…and heard so often discussed the then absorbing topics of 'state rights,' 'free trade,' 'tariffs,' and 'banks.'"[123]

In 1840, Louisa married David James McCord of St. Matthew's Parish and Columbia. He was a prominent lawyer, banker and editor; the author

of numerous legal works; a state legislator; and a devoted advocate of the doctrine of nullification. The fifteen years of Louisa's marriage to David J. McCord before his death in 1855 were the richest and busiest for her in terms of her writing. During this period, she was published in such journals as the *Southern Quarterly*, *DeBow's Review*, the *Southern Literary Gazette* and the *Southern Literary Messenger*. Her drama *Caius Gracchus*, a book of poetry titled *My Dreams* and her translation of Bastiat's book were all published under her name, but her political and social essays and reviews were usually published anonymously—though some were signed with her initials, L.S.M.

The McCords divided their time between Lang Syne Plantation (in what is now Calhoun County, South Carolina) and their home in Columbia. Three children were born to the couple: the aforementioned son, Langdon Cheves, and two daughters, Hannah and Louisa Rebecca. During the family's winters in the country, Mrs. McCord made a daily round of supervision on horseback as the plantation mistress. One of her daughters wrote that she took her responsibilities to her servants very seriously and devoted much time and thought to their happiness and welfare.

The war that began in 1861 ended most of Mrs. McCord's literary efforts. She turned all her energies instead to the support of the Confederate army. When General Sherman's army descended on Columbia in February 1865, Mrs. McCord refused to leave her house, and as a result, she and her two young daughters would soon face a terrible ordeal.

General Oliver O. Howard, General William T. Sherman's second in command, used the McCord house as his headquarters during the occupation of the city. Just before Howard arrived, a crowd of Federal soldiers began ransacking and pillaging the house. One of them seized Mrs. McCord by the throat and tore a watch from her dress. When General Howard arrived, the soldiers were still at work, and he saw his men looting and later caught them attempting to set fire to the house.

That morning, before Howard's arrival, Mrs. McCord had received a note advising her to leave the city. She wrote of it:

> *One of my maids brought me a paper, left, she told me, by a Yankee soldier; it was an ill-spelled but kindly warning of the horrors to come, written upon a torn sheet of my dead son's note book, which, with private papers of every kind now strewed my yard. It was signed by a Lieutenant—of what company and regiment, I did not take note. The writer said he had relatives and friends at the South, and that he felt for us; that his heart bled to think of what was threatened. "Ladies," he wrote, "I pity you; leave this town—go*

anywhere to be safer than here." This was written in the morning; the fires were in the evening and night.[124]

In a letter written shortly after these events, Mrs. McCord's daughter Louisa (later Mrs. Augustine T. Smythe) described how she and other family members fled upstairs when they heard that the Yankees were approaching and heard the soldiers, who began pillaging their yard, their outbuildings and, ultimately, their house:

We bolted up up stairs ready for them & well it was we did, for in a short time the yard was crowded with these vile creatures on foot & on horseback, kicking open doors, picking locks & altogether tearing up the place about as effectually as it could well be done. They stole everything, literally everything that could be carried, actually stuffing lard into their pockets. Everything that could not be carried was smashed…Knowing that they would kick the door down in no time, Mamma unbolted it & then they just over ran the house she just following them to keep them from the stairs…Just in the midst of all the fuss down stairs, while Mamma was having a nice time, one of the men having pushed her up against the wall and dragged her watch off, while another flourished a handful of stolen knives in her face, and all the rest behaved themselves in somewhat the same way, stealing & smashing & were at last beginning to look up stairs, some one rang the bell & in walked Gen. Howard & his staff come to look for quarters…

We never left our rooms except for a little while after dark when we walked in the upper piazza…I then went out to look at the fire, it was a fearful sight…We seemed almost surrounded by the flames and with the wind blowing so furiously we thought it impossible than any house should escape…The house caught twice but was put out, the general to do him justice trying to save it, though his men did their best to let it burn & vowed in the yard that it should burn the next night. That was an awful night, not that I was frightened or even distressed at the time, but it was a horrid feeling to be so at the mercy of the these men when you could see how they rejoiced at all their work. The whole night long there was the most horrid confusion. Yells & curses & worse than all their horrid laughter & jokes & then by way of adding to it they were throwing shells & hand grenades about the whole night. Crowds of women and children gathered in the park & the Yankees actually stood on the hill above & threw the hand grenades among them. We had an encampment right in these pines which gave us the full benefit of their performances…[125]

In another letter, young Louisa marveled at how the Federal officers tried to pretend that the burning of Columbia had been accidental:

> *Oh the hypocrisy of those Yankees! It was wonderful to see how the officers tried to make us think the fire accidental as if we had no eyes & ears to find out for ourselves. I could scarcely keep my countenance. When a piece of cotton was found burning in our entry, the General Howard commenced speaking of the dreadful wind & the strange way in which cotton had been blowing about all day. He tried his hand too to humbug us about the shelling...*[126]

Louisa was referring to a conversation that took place between General Howard and her mother when a wad of burning cotton was found inside an enclosed back entry of the house. He had commented at the time that it was very remarkable how the cotton kept "blowing about." Mrs. McCord answered him sardonically, "Yes, General, very remarkable, through closed doors."[127]

On another occasion that day, Howard had caught some of his own men attempting to set fire to the McCord residence. He ordered them to stop, but when he saw that Mrs. McCord was nearby and had overheard him, he approached her and laid the blame on the burning cotton "flying about."

Because of General Howard's presence, the McCord residence was not destroyed and still exists today as a historic property in Columbia. Most of the McCord family papers, however, did not survive. The guards who were left there by General Howard after his departure to protect it instead looted the place and destroyed family documents, as well as most of the library. In addition, Mrs. McCord felt it

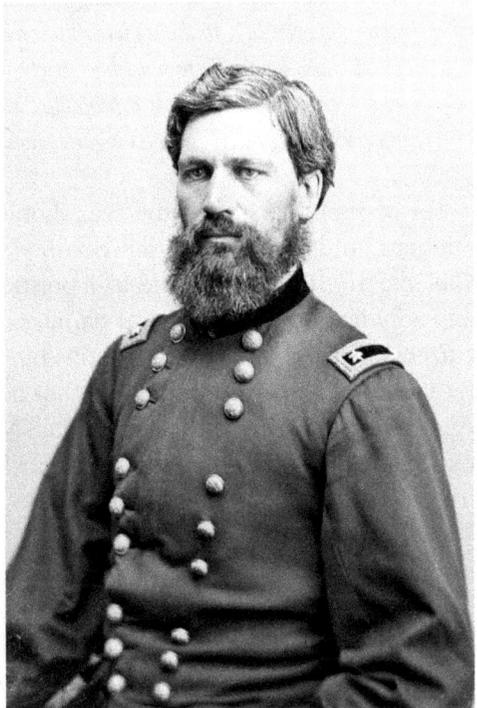

General Oliver Otis Howard (1830–1909). *Library of Congress.*

necessary to burn some of her personal papers to protect her family. Her house at Lang Syne Plantation was also pillaged.

Like other South Carolinians, Mrs. McCord was deeply affected by the outcome of the war, which resulted in the destruction of a civilization she had tried to defend. The heart that had already been broken by the death of a son and her country was broken again when she was finally persuaded to take the hated oath to the United States in order to sell her house in Columbia. In March 1870, during South Carolina's so-called Reconstruction, she penned a poignant letter to the sculptor Hiram Powers inquiring about a portrait bust of her father that had been commissioned before the war. In it, she opened her heart to him and poured out her tragic grief and complaint:

> [We] *are destroyed, and I fear as a people past from life forever. The true-hearted among our survivors have to look with pride, only upon our sufferings, and upon the graves of the dead. We fought for our rights and our liberties. Our very boys were heroes in endurance, and in death. But now, ground down, and writhing beneath the heel of a brutal conqueror, none can even live, without giving up something of the purity of his feelings by submission to the unblushing utterly lawless tyranny of a brutal rule; and the wreck of as noble a people as ever trod God's earth, must, I fear, inevitably fall away from its higher characteristics.*[128]

For several years after the war, Louisa S. McCord lived with various relations, and in 1871, she left South Carolina and resided for a while in Canada. In 1873, she made a deposition for a commission investigating and adjudicating claims for war damages incurred by British and American citizens, giving her account of the burning of Columbia. In 1876, she returned to Charleston to live with her daughter Louisa and her son-in-law Augustine T. Smythe. Three years later, Mrs. McCord passed away and was buried in Magnolia Cemetery. After her death, Isabella D. Martin wrote a tribute to her, part of which read:

> [H]*er eloquent pen was devoted to her country's service as was every fiber of her being. Perhaps her last public writing was an appeal to the women of this State to join in the effort to raise a monument to South Carolina's Dead of the Confederate Army. When some of the women of Columbia inaugurated this movement they naturally turned to her as their leader…*
>
> *The silent sentinel on that monument, keeping guard over the deathless memories of the past, does not attest more fully to the valor*

and patriotism of the men in the field, than it does to the heroism and fidelity of the women at home, foremost among whom was Louisa S. McCord of South Carolina.[129]

The monument to South Carolina's Confederate dead was unveiled in Columbia in 1879, the same year that Louisa S. McCord died.

MARY AMARINTHIA YATES SNOWDEN: "THE INCARNATION OF SOUTHERN WOMANHOOD"

Mrs. Mary A. Snowden (1819–1893) of Charleston was one of many South Carolina women who dedicated themselves to the Southern cause and the welfare of its fighting men and their families. Before the war, she was active in patriotic causes, most conspicuously in her work to honor the South's foremost statesman, John C. Calhoun of South Carolina. Soon after his death in 1850, Mrs. Snowden took a prominent part in an association that was organized for the purpose of erecting a monument to his memory.

She was widowed in 1863 when her husband, Dr. William Snowden, died while serving as a surgeon in the Confederate army. By then, Mrs. Snowden was already a leader in war work, and she continued in her efforts, organizing groups of women to help feed and clothe Confederate soldiers, nurse the wounded and raise money. One of the memorials to her life stated:

> *Under her supervision, and with the aid of other patriotic ladies, a bazaar was opened in Columbia, S.C., which contributed $350,000 to the Confederacy. Special recognition of her services was made by the Congress of the Confederate States by allowing her to import, as best she could, through the blockade, wines and liquors of all sorts for the Southern hospitals. She was present, with her family, in Columbia, S.C., during the sack and burning of that city by the army of General Sherman. Many hundred Confederate prisoners, without means, and generally too weak for transportation, were under her care for some months.*[130]

Mrs. Snowden's work did not end with the war. The Charleston chapter of the United Daughters of the Confederacy recorded her postwar efforts in the following memorial:

She loved the cause for which our heroes fought; she loved the soldiers who fought for the sacred cause so dear to her heart. Nor did her love diminish when the cause was lost, and many of the soldiers had fought their battles and slept their last sleep. The echoes of the last guns of the war had scarcely ceased to reverberate from the Virginian hills, or the islands by the sea, ere she began to arrange for the honorable interment and remembrance of the Southern dead. She travelled from battlefield to battlefield, all over our Southland, gathering up the bones of the dead heroes who were hastily buried where they fell, and brought them to our own city of the dead, and reverently laid them side by side, where, assisted by loving hands, suitable stones were placed to mark their graves. Nor was this all. In 1866 she organized the first Memorial Association of the South, and ever since, year by year, on the anniversary of the death of Stonewall Jackson, the men, women and children of this City by the Sea make their pilgrimage to beautiful Magnolia [Cemetery] to aid this band of noble women in laying tributes upon the graves of those soldiers whose bones she gathered from the widely distant fields where they fell.[131]

In 1867, Mrs. Snowden helped to establish a home and school for the mothers, widows and daughters of Confederate soldiers and sailors in Charleston. She and her sister Mrs. Isabella S. Snowden, her constant companion in war and post-bellum services, mortgaged their own residence to pay the first year's rent on the building that housed this institution.

When Mrs. Snowden died in 1898, she was honored with many tributes, one of which was published in the *Southern Christian Advocate*:

Mrs. Snowden was a remarkable woman, and she rendered a very great service. A Southerner of Southerners, a Confederate of Confederates, she devoted her life to distinctively Southern and Confederate ideas. The monument to Calhoun, the Ladies' Memorial Association, the Confederate section in Magnolia Cemetery, with its hero-dead, the Confederate Home and School, all speak eloquently of the thoughts that ruled a brave, loving and unchangeable heart. This consecration of purpose made possible the large results of her endeavor. Such character and life as Mrs. Snowden's should be held before the generations as an inspiration and an example…Mrs. Snowden was the incarnation of Southern womanhood in the War Between the States and after.[132]

Another tribute to her appeared in a resolution published by an organization of Confederate veterans known as the Survivors' Association of Charleston:

Mrs. Mary Amarinthia Snowden having proved her right to the highest and reverence, and to the warmest affection of those who fought or suffered for the Confederate States by her life-work, is no less entitled in death to have her good and great deeds commemorated and preserved for posterity. Gifted and self-forgetting type of the South Carolina Confederate woman, spending and being spent for those, and "The Cause" she loved better than her life, for four years of war, she lived only to minister to Confederate soldiers and sailors, and for thirty-three years of peace she strove to care for the wounded and homeless Confederate Veterans, and to protect their mothers, wives and sisters, and to educate their daughters, and from far and near to gather the dead heroes of the Confederacy, than in honored graves they might rest in their beloved Southland, and to build monuments (the noblest of them all, "The Home for Mothers, Widows and Daughters of Confederate Soldiers and Sailors," in this city) to teach the lessons they died for.[133]

In 1917, a marble tablet to the memory of Mrs. Snowden was erected in the South Carolina State House by the General Assembly and the South Carolina United Daughters of the Confederacy. It praised her "unquenchable spirit in the aid of the suffering soldier of the Confederacy" and her "zeal to keep his memory sacred."

ANN PAMELA CUNNINGHAM: THE LADY WHO SAVED MOUNT VERNON

Ann Pamela Cunningham (1816–1875) was raised at Rosemont Plantation on the Saluda River in Laurens County, South Carolina. A self-reliant and talented girl, at the age of seventeen, she suffered an injury to her spine when she was thrown from a horse; the accident crippled her with chronic ailments for the rest of her life.

In 1853, when she was thirty-seven years of age, she received a letter from her mother, who was traveling through Virginia, and was distressed to read in it a description of the neglected, decaying condition of the fabled home of George Washington. In a *Historical Sketch* of Miss Cunningham's life published in 1903, the writer gave more details about the incident that led to her life's mission:

It was upon a clear moonlit night in 1853 that the mother of Miss Cunningham passed by Mount Vernon. The steamer's bell tolled out its requiem to the dead hero, whose resting-place, even under the half-tones of moonlight, revealed only neglect and desolation. Reflecting sadly in the silence upon this melancholy scene as it faded in the distance, Mrs. Cunningham realized that unless some immediate effort were made for the preservation of this sacred spot, utter ruin would result. But where should the effort begin? Thinking intently—suddenly, like the flash of the star which shot across the heavens, came the inspiration, "Let the women of America own and preserve Mount Vernon!"

When Miss Cunningham read the letter from her mother containing the proposition, she said, "I will do it."

At this time Miss Cunningham was confined to her room a helpless invalid, whose lack of physical strength was compensated by strength of mind and great intellectual ability, accompanied by an enthusiastic, sympathetic nature which accepted no discouragement or rebuff.

When this delicate, sensitive woman declared, "I will do it!" her friends sought, by reason and ridicule, to dissuade her from so wild an undertaking.

Her answer was the letter addressed through our journals to the "Women of America"—an earnest, stirring appeal to their patriotism, urging them to unite in an effort for the rescue and preservation of this neglected Home, this forgotten Grave—to make of Mount Vernon a shrine sacred to the memory of the Father of the Country.[134]

Miss Cunningham's letter was first published in a Charleston newspaper on December 2, 1853, the writer identifying herself only as "The Southern Matron." Not long afterward, Miss Cunningham founded the Mount Vernon Ladies' Association for the purpose of raising the sum of $200,000 to purchase and preserve this historic property in Virginia. Her initial appeal was addressed to the women of the South, but, as the *Historical Sketch* recounted, it was soon extended to all sections of the country:

The Northern press…began to notice the movement, but condemned the sectional reserve, claiming that the effort should be a National one, and offering the aid of the Northern States. So great was the clamor that Miss Cunningham yielded, and at once began to extend the powers of the Association by the appointment of ladies as Vice-Regents from each state in the Union, with full powers to appoint committees in their respective States for the purpose of raising money.

Mount Vernon, the plantation home of President George Washington. This print, dated 1861, shows the main dwelling, grounds and outbuildings, with tourists in the foreground. *Library of Congress.*

"The Southern Matron," as Regent, was to be the head of the Association. But so extensive a work was necessarily slow in organizing. The difficulty of interesting the people was most discouraging. But in 1855 Philadelphia awoke; great enthusiasm prevailed; clubs were formed; boxes for contributions were allowed in Independence Hall; hope revived; when suddenly the leading men in Philadelphia refused any support for the movement, "because it was a woman's effort, and they disapproved of women mixing in public affairs! Again discouragement, but no halt in the onward course of these patriotic women, who fought on against the tide, inspired by their untiring leader.[135]

One of the many American women who responded to the call for the preservation of Mount Vernon was Loula Kendall Rogers. As a girl, Rogers became the "Lady Manager" of the Mount Vernon Association in her county in Georgia. She later recalled in her reminiscences:

[I] felt no little pride in the thought of what a young girl could do toward preserving the home of Washington as a precious heirloom of our very own, never to be desecrated for other purposes but to be kept sacred to the

memory of the "Father of our Country." No section contributed more than the Southern States, and as he was a true-hearted son of the South, we still value above gold our interest in his lovely home, and its twin sister "Arlington, the Beautiful," which should have been held sacred in like manner, as the home of General Robert E. Lee and his bride.[136]

Under Miss Cunningham's leadership, the association solicited subscriptions for its cause from every part of the country, and in early 1859, after many struggles and setbacks, this goal was reached. The purchase of the property was finally completed on February 22, 1859, leaving only two years "in which to raise funds for the restorations and repairs at Mount Vernon before the Civil War put an emphatic period to all such efforts."

Miss Cunningham lived at Mount Vernon for a short while before the war but returned home to Rosemont when her father died, helping to operate her family plantation throughout the war years. Shortly before the war began, it became known that Miss Cunningham remained loyal to her state after its secession, and there was some concern that the association she had formed would fall apart. But she persevered, refusing to resign as the head of the organization, and continued her work for Mount Vernon through correspondence with a resident secretary and a superintendent present there during the war. The *Historical Sketch* noted:

Miss Cunningham went back to her Southern home, Rosemont, South Carolina, in December, 1860, and during the war administered the affairs of Mount Vernon by letter to Miss Tracy and Mr. Herbert, the resident secretary and superintendent. As the war advanced, however, the difficulty of communicating by letter increased, and there were long intervals when no letters could be sent.[137]

It was due to the efforts and appeals of Miss Cunningham and her secretary, Sarah Tracy, that both sides, Union and Confederate, held Mount Vernon sacred as neutral ground while fighting went on in the surrounding countryside.

When the war was over, Miss Cunningham returned to Mount Vernon, and despite her worsening health, she worked tirelessly to raise more money to maintain and repair the place. She pressed a claim against the United States government for a steamboat belonging to Mount Vernon that had been impressed and used as a troop transport. And in 1869, Congress finally granted the claim and paid an indemnity of $7,000 to be used for the restoration of George Washington's estate.

Not long before her death, Miss Cunningham sent a farewell address to the Mount Vernon Ladies' Association, in which she wrote: "Ladies, the home of Washington is in your charge…let no irreverent hand change it; no vandal hands desecrate it with the fingers of progress! Those who go to the home in which he lived and died, wish to see in what he lived and died! Let one spot in this grand country of ours be saved from change! Upon you rests this duty!"[138]

Ann Pamela Cunningham died at Rosemont Plantation on May 1, 1875, and was buried in the churchyard of the First Presbyterian Church in Columbia. Today, Mount Vernon is still owned and maintained by the organization she founded.

MORE TRUE STORIES OF CONFEDERATE SOUTH CAROLINA

CONFEDERATE POWS ON MORRIS ISLAND: THE IMMORTAL 600

Because of the 1989 movie *Glory*, many Americans know of the battle on Morris Island in 1863 in which the black soldiers of the Fifty-fourth Massachusetts Regiment fought. Very few people, however, are aware of their participation in another wartime event on this barren, sandy piece of land in Charleston Harbor, after Union forces gained control of the island.

In August 1864, six hundred Confederate prisoners of war were taken out of a prison camp in Delaware and transported by ship to South Carolina. The destination for most of these men was a stockade enclosure of logs situated in front of Batteries Wagner and Gregg on Morris Island. These men had been sent down at the request of General John G. Foster, the Union commander in charge of the military department in the area, for the purpose of retaliation. General Samuel Jones, the Confederate commander at Charleston, had been ordered to temporarily accept and incarcerate a large number of captive U.S. officers at several locations in the city. General Foster was aware that these prisoners had been brought to Charleston only out of necessity, but because they were quartered in residential parts of the city exposed to the continued Federal shelling coming from Morris Island, Foster decided to retaliate by placing a large number of Confederate prisoners directly in harm's way.

Beginning in the first week of September 1864, soldiers of the Fifty-fourth Massachusetts Regiment served as guards and wardens at the island stockade prison. During this time, after completing a tortuous journey in the sweltering hold of a paddle-wheel steamboat, the captive Confederate officers disembarked at Morris Island. One of the prisoners, Captain Henry C. Dickinson, recorded their arrival in his diary:

We were met at the wharf by a full regiment of the Sons of Africa, the Fifty-fourth Massachusetts, under command of Colonel Hallowell, son of an abolition silk merchant in Philadelphia. This regiment…amused us by exhibiting their proficiency in the manual [i.e, rifle drill], and thus, as they supposed, impressing us with a wholesome dread of their prowess. We soon started up the eastern beach of Morris Island, guarded as closely by these negroes as if we were in Confederate lines. The gait was so rapid and we so weak that many of us utterly broke down about one and a one-half miles from the wharf, when we halted to rest, and, as it just commenced raining hard, we eagerly caught water in our hats to drink, having had none for twenty-four hours. The negroes, perceiving this, went to a spring hard by and brought us some very good water.[139]

In a memoir, prisoner Lieutenant Henry H. Cook added these details:

In charge of this regiment, we marched into our prison pen, situated midway between Forts Wagner and Gregg. Our prison home was a stockade made of palmetto logs driven into the sand, and was about one hundred and thirty yards square. In this were small tents and ten feet from the wall of the pen was stretched a rope, known as the "dead-line." Outside of the pen, and near the top of the wall, was a walk for the sentinels, so situated as to enable them to overlook the prisoners. About three miles distant, and in full view, was Charleston, into which the enemy was pouring heavy shells during the night while we remained on the island. [Fort] Sumter lay a shapeless mass about twelve hundred yards to the west of us, and from it our sharpshooters kept up a constant fire upon the artillerymen in Fort Gregg. Off to the right lay Sullivan's Island, and we could see the Confederate flag floating over [Fort] Moultrie.[140]

In his detailed diary, Captain Dickinson recounted the artillery duels that went on between the Union fortifications on Morris Island and the surrounding Confederate forts and batteries, describing one early engagement thusly:

Moultrie fired splendidly, only two or three shots falling too short; the great majority fell into Wagner. Most of our shells were from mortars and looked as if they would fall directly on us, but, whilst we held our breath in anxious expectation, its parabolic course would land it in the fort. Every good shot was applauded by us as loudly as we dared. We were but 250 yards from the spot at which these monster shells were directed, and too little powder or a slight elevation of the mortar might have killed many of us since we were so crowded together. But it was a trial of Southern against Northern gunnery...Two shells exploded over us, throwing great and small pieces all about our camp. After these two last shots Moultrie fired no more at Wagner, and this was the first evidence that the Confederates knew our position between the forts.[141]

The prisoners believed that the Confederate gunners knew the location of the stockade and directed their fire accordingly. Although some shells came close or burst overhead, affording the prisoners some hair-raising moments, none fell directly into the prison camp.

From his lofty post in the steeple of St. Michael's Church, Gus Smythe, a young Confederate signalman, observed events on Morris Island through his telescope. He wrote to his mother, "I can see the men in the morning getting their rations & also see the poor fellows looking through the cracks of the fence. How tantalizing to them & us, thus to be within sight of each other, but so out of reach!"[142]

The stockade prison guards were sometimes trigger-happy, firing into the camp for what one prisoner described as trivial offenses, wounding several men. But in general, the Confederates got along well with the black sergeants who served as their wardens. Prisoner Captain George W. Nelson recalled these men and their white commander, Colonel Edward N. Hallowell:

Our camp was laid off in streets, two rows of tents facing each other, making a street...A negro sergeant had charge of each row, calling it "his company." These sergeants were generally kind to us, expressed their sorrow that we had so little to eat. We had a point in common with them, viz: intense hatred of their Colonel. Their hatred of him was equaled only by their fear of him. His treatment of them, for the least violation of orders, was barbarous. He would ride at them, knock and beat them over the head with his sabre, or draw his pistol and shoot at them.[143]

The Confederate officers remained on Morris Island until the later part of October 1864. For much of their sojourn on the island, food rations were

inadequate, and many men suffered from dysentery and other complaints. Three of them died and were buried there.

When the prisoners learned that they would be leaving Morris Island, they were overjoyed, but they would soon discover that they were exchanging a bad situation for one much worse. Lieutenant Cook recalled their departure:

> On October 26 we were informed that we were to be taken to Fort Pulaski, at the mouth of the Savannah River. We were in the hands of Foster, and no mercy was expected or hoped for. We staggered or were hauled to the wharf and were placed upon the little schooners to be towed to Fort Pulaski. The horrors of Morris Island were not to be compared with what awaited us on the coast of Georgia.[144]

At Union-held Fort Pulaski near Savannah, these Confederate prisoners of war would undergo an extraordinary retaliatory regime of severe rationing and other deprivations—an ordeal that would later make them famous as the "Immortal 600."

THE SUMMER FAMILY OF NEWBERRY COUNTY

In 1840, William Summer established Pomaria Nursery at his family's plantation in Newberry County, South Carolina, adding a branch in Columbia in 1860. He was well known as a horticulturalist, his expertise lying mainly in fruit trees and certain flowers. His friends and acquaintances in the field included noted naturalist Dr. John Bachman and Reverend John Grimke Drayton, who was famous for his beautiful Magnolia Gardens near Charleston. William Summer was also a gifted writer and a "philosopher of gardening." With his brother Adam G. Summer, he edited a magazine called the *Southern Agriculturalist* and wrote many fine essays for it and other publications. He imported rare plant specimens from Europe and other parts of the world and brought in European gardeners to work for him at his nursery, which came to be known as one of the best and largest in the South. Adam G. Summer, who was skilled in the cultivation of native and exotic trees and shrubs, developed new varieties of these plants at his nearby plantation called Ravenscroft.

In February 1865, Ravenscroft Plantation was burned to the ground by Sherman's troops. At Pomaria, soldiers pillaged the house and set fire to

it several times. And though the family was able to extinguish the flames and save it, the nursery buildings were burned and largely destroyed at both Pomaria and Columbia.

Another Summer brother, Henry, who lived at Crossroads Plantation near Newberry, also suffered great losses during the war. Many details are known about the experiences of Henry Summer and his family. He practiced law in the town of Newberry, and when the courts ceased operating in 1864 due to the exigencies of the war, he moved to his plantation, witnessing its destruction the following year. He owned a large, fine library, much of which was destroyed when his house was burned down.

In his book *Reminiscences of Newberry*, John B. Carwile wrote of Henry Summer:

> *He was the son of Captain John Summer, and was born at Pomaria, Lexington District, S.C., on the 11th of April, 1809…Both his paternal great-grandfather and his grandfather (Nicholas Summer) were soldiers in the American army during the Revolution…On the 22d of December, 1846, he was married to Miss Frances Mayer…He was elected a member of the House of Representatives of South Carolina in 1846, and was re-elected to the same position in 1848…He was a great lover of book; the enthusiasm he displayed in collecting the best editions of the works of celebrated authors amounted almost to bibliolatry…*
>
> *In the latter part of the year 1864—the Courts having been virtually suspended—Mr. Summer moved from Newberry to his farm in Lexington District. During Sherman's memorable march through the State in 1865, Kilpatrick's command—as it swept over that portion of the country which lies along the western bank of Broad River, between Columbia and Alston—destroyed Mr. Summer's houses and other property; and some soldiers went so far as to prepare for the hanging of Mr. Summer himself.*[145]

Henry Summer died in January 1869. Two decades after the war, Carwile asked Henry Summer's widow to write down her family's experiences. She replied to him in a letter, giving what he described as "a most faithful narrative of the sufferings of the family at that time and of the inhuman treatment to which they were subjected."[146]

POMARIA, January 18th, 1888

My Dear Sir: I received your letter a few days since, and will endeavor to comply with your request as well as I can. After the lapse of twenty-three

years, with their accompanying trials and sorrows, many things have passed from my mind.

Saturday morning, 19*th* of February, 1865, we apprehended no immediate danger, as Wheeler's men had been passing all day Friday, and two Confederate soldiers lodged with us that night; and early Saturday morning, two men, professing to be friends, assured us that none of the enemy were near, although we knew that there had been fighting around Lexington the day before.

It was not long before we saw columns of smoke arising below us, and gradually nearing us. While looking with much fear on this, we were greatly alarmed at seeing a body of ferocious-looking men charging up the Lexington road that crossed Prosperity road in front of our house. They surrounded and entered the house, and the work of plunder began. We realized that we were helpless, with no friend near us, and at the mercy of thousands of lawless men, under no restraint. My husband hoped that his age and feeble health would shield him from abuse and violence, but the events of the day proved his mistake. He had on a light suit of jeans, as the weather was mild, but kept his large shawl near, to throw around him when he needed it; that they seized for the first thing and all his clothing followed, but what he had on. By this time they came swarming in from every direction, until the yard and surrounding grounds were filled with armed men charging about, and even attempting to ride into the house; and the work of destruction went on. Every door, trunk, and bureau was broken open with hatchets, if the lock did not yield immediately, and the contents carried off, or scattered over the floor, to be trampled under their feet, or picked up by others, who crowded in after them. As one party passed out, loaded with what they fancied, another came in; so that the house was packed with the vile wretches all day. I cannot now remember nor repeat all their abusive and insulting language. My husband's pockets were searched many times and every thing taken, but a pocket calendar; the last man seized that, thinking it was a silver coin, but another man, standing by, ordered him to restore it, which he did. About one o'clock the large barn and other buildings in the lot were burned.

We were told by some of the better men, that all this plunder and destruction was done by stragglers, who went ahead of the army, under no control, but when the regular army came up, disciplined and controlled by officers, we would be respected and protected; but that was not so, for in the midst of this confusion Kilpatrick came up, looked on with indifference, and saw his men carrying out every moveable thing to the roadside, to

*await their wagon train. He commanded the left wing of Sherman's army,
eight thousand strong, mostly cavalry, but he must have had a large force
of infantry, for while he was at the house they marched by; and both roads
fronting the house, as far as the eye could see, were so densely packed with
men that no one could have passed between them; while around the gate,
over which a large United States flag was floating, cavalry and infantry
seemed to trample upon each other.*

*As soon as I learned Kilpatrick was at the front steps, (he did not enter
the house, but his staff and others crowded into my room where I and my
children were) I made my way, unaided, to him. My husband was standing
in front of him, civilly answering such questions as he asked, such as the
route to Hughey's Ferry, to Alston and Ravenscroft. I caught him by the
arm to attract his attention, and begged, as only one in my extremity could,
for protection. He impatiently answered: "I am busy, go to the Provost
Marshal." I found him standing by the front door, inside the house, who, in
answer to the same request, said: "That nothing could be done." But that
was another falsehood; for, while Kilpatrick was talking with my husband,
a large column of infantry was marching down the road to Hughey's
Ferry—he quietly said to some one standing by: "Halt that column!" and
in a few minutes they had turned into the Alston road; showing how well
disciplined they were, and how quick to obey orders.*

*After Kilpatrick had all the information he wanted, he rode off, leaving
us to our fate, not caring what it would be. When the sun went down, the
men were all ordered within the picket lines, and we were left to ourselves.
Then the horrors of the night began. We could not sleep, or let the light
go out, fearing that the house would be burned over our heads. Only the
younger children lay down to sleep, while the rest of us sat up during the
long night, and kept a bright light. It was during that fearful watch that
my husband told, for the first time, the trying ordeal through which he had
passed that morning. Three or four of the savages forced him to go with
them to the barn, and while they were putting a rope around his neck,
demanded his gold and silver. He told them he had no gold, no money at all,
for all had been already taken from him. They then made him stand on a
sill, or something raised from the floor, and again demanded gold, declaring
that they would hang him if he did not give it up. They then threw the rope
over a peg high up on the wall, and made the same demand with the same
threat. My husband, believing that death was very near, closed his eyes,
and offered up an audible prayer for himself and also for the men who were
about to murder him. That prayer, or something, seemed to touch one of the*

number, as he called the others aside, and after consultation, returned and told him to come down, but they still believed that he had the gold.

Sunday morning dawned, and with the light our troubles began, and the whole day we were harassed by foraging parties of eight or ten who would gallop around the house like madmen, tramp through the house, look into the room where we were sitting, make some taunting or insulting remark, and then go out to make way for others.

I must not omit here to say, that after early breakfast Saturday morning we had nothing to eat—everything was taken from us. After night one of the servants went into the storeroom, and, sweeping and dusting the hominy barrel, got enough to make a scanty meal, by boiling husk and all. That we ate as well as we could, without spoons or knives. Sunday morning we found some rice left, and that was all we had to eat until we came away.

Sunday, about 2 o'clock, as we were sitting in our room, dejected and miserable, not knowing what the next hour would bring to us, two men rushed hastily into the room; one of them seized a match and said: "Give me one hundred dollars, or I will burn your house." With that he rushed up stairs, where everything combustible was scattered over the floor. My husband said to his companion: "Surely you will not allow that man to burn my house." He replied, indifferently, that he did not think he would do it. By this time the wretch had applied the match to papers and cotton at the head of the stairs, and in five minutes everything was blazing. There was no water at hand, and we made no attempt to put out the fire, for the servant women, as well as ourselves, were too much exhausted to do anything but gather up a few things that were lying about on the floor, and make our escape to the orchard. Two of their men galloped up at this time, and did everything in their power to save everything from the burning building. They managed to take out the bed in my room and the children's beds. While we were sitting by the little pile of things saved, we were still annoyed by the savages, for parties of them would ride around us, shoot their carbines, dismount and turn over whatever was lying about us, to rob us still further, if they saw anything to suit them. Some of them told the negroes that if we went into their house, which was the only one left, they would come back that night and set it on fire. We therefore remained in the orchard until dark, and each one was thoroughly chilled. Hoping, then, that the last one had gone within the lines, we ventured to go into the negro house, where we passed another miserable night.

When Monday morning came, we could not see ten steps from the door; we were girded by fire, the woods having caught from the burning houses.

The smoke was so dense that when the sun arose it looked like a ball of fire. The desolation was indescribable. Our nearest neighbor, who had been hiding out, now came up, and told us that the whole army had gone.

Monday evening, about 4 o'clock, a message came from brother William Summer for us to try and get to his house, as they had a little bread and shelter left. So we started and walked the distance of four miles, the youngest child being only seven years old. Our children behaved admirably during that trying time; John was thirteen and Kate seven. Although frightened, they were calm and quiet, and never once asked for anything to eat, which would have added much to my distress, for I did not have it to give them.

The crowning evil and injury caused by the events just related was yet to follow. I shall always believe that my husband's death was hastened by exposure with insufficient clothing to the inclement weather that followed shortly after, and anxiety about the condition of his family, and great losses. True he was an invalid, but the great care that he took of himself would have prolonged his life many years perhaps.

Very respectfully, your friend,
FRANCES SUMMER[147]

Shortly after the war ended, on April 22, 1865, Henry Summer wrote a letter to the governor of South Carolina, Andrew G. Magrath, giving the story of what happened to him and his family in February 1865—events that he described as being imprinted on his mind "as if written with a pen of fire." The details of his letter closely match those recalled by his widow in the letter she penned more than twenty years later. Summer reported to the governor:

A few days ago (18th instant) I received a communication from Dr. W. Gilmore Simms of the date of the 3rd instant, desiring information as to the extent of the losses in property—"houses, horses, cattle, mules, hogs, valuables of all sorts, tools, etc. and what, if any, were the especial enormities practiced upon citizens." The time is too short to write to Dr. Simms in Columbia; and I have concluded to write directly to you of the treatment I received at the hands of the enemy. Without any preliminary statement, I proceed to give you some detail of their actions. The first man of the enemy that I saw, accosted me very roughly, and demanded my gold watch and silver that I had hid, presenting a pistol at my breast. Three or four men were with him all on horseback. I was so stunned & shocked that

I told them where these valuables were concealed. They got them. Before I reached my house some of the same crowd who had come to the house had forced from me my Confederate money, about eleven hundred dollars. Shortly before this, for as yet I had not set foot in my house, a Mr. Williams restored to me for my wife a beautiful strawberry dish, which I handed to her in his presence. By this time the yard was filled with armed men plundering the house, breaking locks, splitting open trunks, and taking away any thing & every thing they chose. Some were plundering the meathouse taking hams, shoulders, middlings, sausages, etc. Others came taking sugar, syrup, meal, flour & etc, filling with these articles, the pillow cases, tying up many things in the sheets.

In the mean time, two men, accompanied by some others, compelled me to go with them to the stable, demanding of me gold & silver money to the amount of three thousand dollars which they said, they were informed I had concealed. To compel me to disclose where the treasure was they threatened to hang me, took me into the stable, made me get up on a plank nailed up against some upright posts; one of them made a noose, and ordered me to put it around my neck, and then fastened the rope to a pin which ran through a post about a foot and a half above my head. In this condition I offered a prayer to God to protect me. The man then went out of the stable and closed the door. After a little while he returned, and let me down, saying that he would let me go, but that he believed I had the money. I protested to them that I had not. After some other conversation we parted.[148]

In a letter of 1867, Henry Summer added more details about the soldier who tortured him:

I asked him, just as he was mounting his horse, what his name was, and where he was from? "Green, and from Ohio," was the reply. I looked him direct in the face, and asked him if he ever prayed. He said, "Sometimes, when I am at home." I said to him, "Will you pray for me?" He said: "He would when he got home." I then replied, with earnestness and emphasis: "I can pray for you." He then mounted his horse and rode off.[149]

Summer's letter of 1865 concluded:

I then returned to my house and shortly after Gen. Kilpatrick rode up to the front gate, dismounted and came into the yard. Mrs. Summer went to him and asked him to protect her house (which was then full of armed men

*going through it & plundering). He told her to go to the provost marshal,
and asked for me. As she was inquiring for the provost marshal, she saw
me and told me that Genl. Kilpatrick was in the yard and wanted to see
me. I went to him and asked him to protect my house. He replied, "I am
carrying out orders."*[150]

THE ORDEAL OF JOHN FOX

During the march through the Carolinas, it was a common practice for
the soldiers of Sherman's army to hang or threaten to hang civilians in
order to extort information about hidden valuables. John Fox (1805–1884),
a prominent citizen of Lexington District and one of their victims, wrote
about his harrowing experiences in a lengthy affidavit. He resided in what is
now Lexington County, near Columbia, and was at his plantation as Federal
troops came into the area to lay siege to the capital city.

*The following is a statement of some of the particulars of the treatment to
my person and property by General Sherman's army on the 15th, 16th and
17th February, 1865. I have and had at that time a residence near the village
of Lexington Court House and a plantation within four miles of the same
on the road leading from Lexington Court House to Wise's Ferry…There
was a very large force stationed along this road…and preparations were
being made as though they expected a battle…My wife and two daughters
were at my residence in the village and I was at my plantation and all my
sons (three in number) were in Confederate service…The army reached the
village in the evening of the 15th Feby. My family informed me that soon
after dark a party of men came into the house whom they took to be officers
and said they were Yankees and acted gentlemanly and asked for honey (I
had a considerable number of bees both at my residence and plantation,
all of which were destroyed by that army). They stated to my family not
to be alarmed as they should not be troubled. They were furnished with
some honey and left. The camps were very near my residence and in a
very short time another party came armed with guns and in a very rough
manner saying that they were looking for arms and tobacco. They were
informed there was none there. They paid no attention to that and took
candles and went into every room in the house, every chest, trunk, box,
drawer, closets and every conceivable place that it was possible for anything*

to be and carried off everything valuable that they could lay their hands on, provisions, clothing, bed furniture. Myself and my family were left so bare that it was with the greatest difficulty we could change our clothing of the most common kind…I had a house furnished at my plantation and that was completely cleaned out. We were left without anything to eat…

On the morning of the 16th Feby. a party of mounted men met me in my yard at my plantation well armed. The first two that reached me took hold of me and commenced cursing me and asking "where was them rebels" and where were my horses, etc. They jerked and pulled me about very violently and [took] my watch and all the money I had on my person…They took everything I had about my person then except my clothing…I was searched very often that day for money by new crowds as they would come in.

I remained in my piazza most of the time, and many of them would have a passing word to me in very abusive language…Many of them were abusive to me in language, in presence of the negroes, threatening me severely…They would not permit the cook to give me one mouthful of nourishment and threatening continually to burn the dwelling house and…burning nearly all the negro houses…There was a great crowd all day; as some would leave others would come. Late in the evening a large frame man in a very rough manner took a fine and heavy beaver cloth overcoat I had on at the time and had been wearing it all day. Stripped me of it. I sat down then by the fireplace. I had become very much exhausted by that time and very feeble indeed. I had not remained there very long when three tolerably stout athletic men approached me…As soon as they commenced talking to me I came to the conclusion that they had not the least particle of humanity about them, but I still thought them intelligent. They commenced with me very stern and rough asking me where my specie was and stating that one of my negroes had informed them that I had on the evening before gone in a certain direction with a box under my arm…They stated they had been tracking me…They did not succeed very much in getting any satisfaction out of me. One of them stepped to a bedstead that had a rope for a cord. They cut out a portion of it. They then took hold of me…adjusted the rope preparatory to hanging me and placing it around my neck in a very rough manner and ordered me to get up. One of them held on to one end of the rope while the other was on my neck and hurried me out of the house.

They mounted their horses well armed and…pulled me along as rapidly as it was possible for me to go. They were very abusive to me on the way. They were on horseback and I on foot. They went…some four hundred yards into a thicket of old field pines. One of them threw his end

of the rope over a limb of a pine and then had taken hold of it again, still trying to make me discover to them where the treasures were deposited and said to me if I would they would be liberal with me; they would divide whatever it might be. I still persisted for I had all my important papers which was for a very large amount for myself and for estates that I was interested with…all of which I was under the impression they would take and destroy. The man with the rope drew me very hard and let me down, then questioned me and failed to get the satisfactory information, and drew me again more severe and let me down and still they failed to get the desired information, and drew me up the third time. When I became much exhausted indeed he let me down.[151]

After being drawn up by the rope a third time and fearing for his life, Mr. Fox relented and agreed to show the soldiers the location of the box he had hidden. He pleaded with them for his important papers, and when they found the box, they left these alone but took all his specie (gold money). He reminded them that they had promised to divide the spoils with him, and out of several hundred dollars in gold they gave him one twenty-dollar piece. The next morning, more soldiers returned to his plantation.

There was a great crowd there early the next morning taking what they could find. It was not very long before the meanest looking creature that I ever saw in human shape, of tolerable large frame, his head looked as though it had passed many weeks since it had any attention. I never expect to see as hateful looking a being again in all my life. He could tell me of the ordeal I passed through the evening before, and of the twenty dollar piece, and demanded it of me and compelled me to give it to him or be shot. It was not very long before a diminutive looking creature of desperate appearance with his gun in his hand demanded of me money stating that it was two pieces in place of one and swore he would shoot me. I replied to him that he would have to shoot and then not get any money…Some of the crowd then interfered in my behalf…As new crowds would come up, there would be some among them that would continue to press on me for money, and threatening to burn. Some would say that I had seen nothing yet but I would see fun today by burning, etc. One or two of them spoke friendly to me—that was on the 17th Feby. and advised me to go to headquarters at the village for protection and advised me how to pass through the lines. I concluded to do so, as there was very little left then and I was anxious to know how my family was doing. Every horse and mule, saddle and bridles

had been taken. The first day I thought it was impossible for me to make the trip on foot but I made it after a time. After I started I discovered the troops were…leaving their encampments. The whole country seemed to be on fire and the wind very high. I discovered that most of the village was burnt and burning and the fencing and wood burning very near my dwelling. The army had then left the village except a few scattering men. As I reached my dwelling two rode into the yard and ordered me not to move and went to the kitchen fire and said they would show us what secession was. My family became very much alarmed and pled very hard for them not to burn the house, and for time to remove some little matters that were still left them. They after passing around the house a time or two and making many threats and abusive remarks left without burning the house.[152]

The Fox house survived the war and was acquired and restored by the Lexington County Museum in 1969. It was the first structure in that county to be placed on the National Register of Historic Places.

WILLIAM PORCHER DUBOSE OF WINNSBORO

"The world requires two different classes of laborers to carry on the operations of society," William Porcher DuBose wrote to his fiancée in April 1862, "men of thought, reflection and study, and men of action."[153] DuBose placed himself in the former class, but in the terrible ordeal of war, he proved himself to be one of those rarest of individuals—a man of both thought and action.

A native of Winnsboro, DuBose had dedicated his life to God and was preparing to enter the Episcopal priesthood when the war began. But after much soul-searching, he left his seminary studies to become an adjutant in the Holcombe Legion. Initially state troops serving in the coastal defenses of South Carolina, the Holcombe Legion eventually became part of Brigadier General Nathan "Shanks" Evans's Brigade, a unit also known as the "Tramp Brigade" because it saw service in so many different areas during the war.

In 1862, while Evans's Brigade was fighting in Virginia, DuBose was wounded at the Battle of Second Manassas. Not long afterward, he was captured at South Mountain in Maryland. Having been ordered to conduct a nighttime reconnaissance in the area after the day's fighting, he went to the scene of earlier fighting, leaving his men at the foot of the mountain,

and then disappeared. For a while, no one was sure if he had been captured or killed, and his commander and friend, Colonel Peter F. Stevens, feared the worst. As it turned out, however, DuBose had been taken prisoner during his scouting mission. He was sent to Fort Delaware, Delaware, and after a brief imprisonment, he was exchanged and returned to Richmond, Virginia, where he had the strange experience of reading his own obituary, as he had been presumed dead. Evans's Brigade soon left Virginia and traveled to North Carolina. There, at the Battle of Kinston in December 1862, DuBose

William Porcher DuBose, later known as the "Sage of Sewanee." *Photograph courtesy of the Deane DuBose Stevens family.*

was shot down while courageously leading his men, receiving such a serious wound that it was at first thought he would die from it. While convalescing, he wrote to his fiancée about the fighting at Kinston and the kindness shown to him by General Evans:

We reached Greenville on Wednesday, remained there Thursday & were ordered back on Friday. We marched back to Kinston (33 miles) by midday Saturday & were ordered in at once to meet the enemy. The skirmishing had ceased when we reached the ground, & we were put into position in the immediate centre with the expectation of an attack at daylight next morning. You may imagine how much sleeping was done by our 2000 men awaiting the advance of 20,000. About ten O.C. on Sunday came one shot from our advanced picket, then another and another, each nearer than the last. Words cannot express the feelings excited by those isolated reports falling at last upon ears which have been listening for them for hours. The man who has been through battles & knows what they are must have strong nerves

to keep a constant pulse & a steady hand at that trying moment. That is the time for cool officers. A command given in a trembling voice just then might produce a panic or even a stampede, where such odds are expected. We were not kept waiting long. The roar of artillery & musketry soon became deafening & the men soon warmed up with work & then really behaved well. We were growing quite enthusiastic…when at the very crisis of the engagement and at the very pitch of the excitement & enthusiasm I was shot & immediately borne off the field in a litter. As I passed by the General he enquired who it was & when he was told came & grasped my hand & said "You always were a gallant man, sir." He then gave me a drink & made me bathe my face in brandy which revived me very much. He was very kind to me afterwards, sending his Chief Surgeon to see me & speaking in rather flattering terms about me.[154]

Though there are many grim events recorded in DuBose's letters, there is also humor, as well as many beautiful expressions of his ardent devotion to Nannie (Anne Barnwell Peronneau), whom he married in April 1863 and whose love was, as he wrote to her, "next to God's love, the highest & most precious reality" for him.[155]

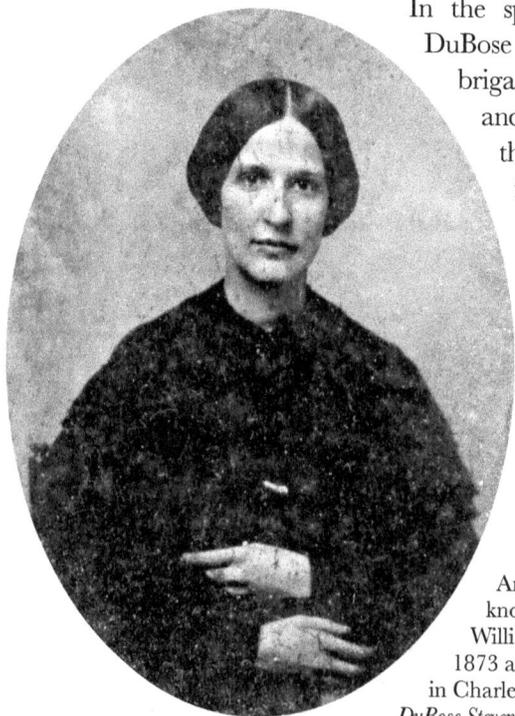

In the spring and summer of 1863, DuBose was in Mississippi with his brigade during the Siege of Vicksburg and fighting near Jackson. Toward the end of that year, two influential friends, Thomas F. Davis, the Episcopal bishop of South Carolina, and General Joseph B. Kershaw, secured his appointment as a chaplain in Kershaw's Brigade. The following year, in February 1864, DuBose

Anne Barnwell Peronneau DuBose, known as Nannie, beloved wife of William Porcher DuBose. She died in 1873 and is buried in Magnolia Cemetery in Charleston. *Photograph courtesy of the Deane DuBose Stevens family.*

traveled to eastern Tennessee to take on the grave, often daunting responsibility of the spiritual welfare of hundreds of soldiers and officers. One of his most vivid letters records a winter trek through the gloomy, majestic, snow-covered mountains of North Carolina while he was on his way to join up with Kershaw's Brigade. During the journey, only a "chance" encounter with a lone woman in this wilderness saved DuBose and his party from riding directly into a nest of bushwhackers and certain death.

In the last, most tragic days of the war, Kershaw's Brigade was sent to South Carolina and finally into North Carolina in an effort to resist General Sherman's army. From what DuBose wrote in his letters at this time, it is evident that he and many others did not dream that a final defeat was near, and he even mentioned that morale was high as they battled on. When the end did come, and DuBose learned that the cause was lost, the news affected him (as he recalled in his memoirs) "like a shock of death."[156]

Writing to Nannie early in the second year of the war (February 28, 1862), DuBose speculated on the possibility that the Southern cause of independence might fail and that, if this happened, it might be that it was God's way of teaching his people a lesson "that here 'we have no continuing city,' but that 'we seek a better, even an heavenly.'" DuBose went on to say that "we ought to remember that we belong to a kingdom that is above the kingdom of this world" and that the Christian life "consists in the gradual withdrawal of our affections from things temporal & fixing them upon the eternal."[157]

For the young chaplain, the defeat and subjugation of his country, the end of his world, resulted in exactly such a redirection of his life. In his memoir *Turning Points*, DuBose wrote about the night he realized that the Confederate cause was lost: "I could not sleep; the end of the world was upon me as completely as upon the Romans when the barbarians had overrun them…the actual issue was all upon me that fateful night in which, under the stars, alone upon the planet, without home or country or any earthly interest or object before me, my very world at an end, I redevoted myself wholly and only to God, and to the work and life of His Kingdom."[158]

The following is part of a letter from DuBose to his wife, written from Virginia, after fighting at Strasburg and Cedar Creek in October 1864. Another South Carolinian, General James Conner, was in command of Kershaw's Brigade at the time. The Colonel Rutherford mentioned was William Drayton Rutherford of Newberry County, South Carolina.

I wrote you a pencil note on Tuesday night, my Darling, from near Mt. Jackson. My time since this has been spent rather sadly. On Wednesday we

reached the place and found the entire Yankee force in position a few miles beyond the town. Gen. Early immediately put a few pieces of artillery into position and opened fire upon them. An attempt on the part of the Yankees to capture these pieces brought on a partial engagement in which our brigade alone was actually engaged. Gen. Conner made a very handsome little fight, killing and wounding a large number of the enemy, and taking one hundred prisoners. Our loss was about one hundred & thirty. Gen. Conner had his knee shattered by a piece of shell necessitating amputation. The shock was terrible to his system, as is always the case with shell wounds, and he was so prostrated after the operation that the Dr. was afraid he would not rally. He did so, however, and is now getting on admirably. The leg which he has lost had never recovered from a wound received at the Battle of Seven Pines, so it was no very great loss to him. The loss of Gen. Conner to the brigade is an irreparable one. I consider him the best officer I have ever known & he was getting the brigade into splendid condition. I think he expects to return on a wooden leg.

My friend Col. Rutherford was mortally wounded in the centre of the body. We got the Genl. and himself into adjoining rooms in a house where he died yesterday at 1 p.m. after about twenty hours of torture. I was with him all the time and have never had my heart more wrung by the sight of suffering. He had been trying for some weeks or months to prepare for death, but could not feel that he was accepted & his sins forgiven. As his end drew nearer & nearer he seemed to trust more & more in God's mercy and at the last he told me he was willing to go. But his efforts to be patient under his great suffering were most touching. He felt that it was God's hand laid upon him and never once rebelled. He kept praying "if it be possible let this cup pass away from me," and when I asked him if he could finish the prayer he said "Yes, but not my will but thine be done."

The whole scene was the most heartrending and affecting that I have ever witnessed. There is another poor young widow added to the number made by this terrible war...[159]

After the war, DuBose was ordained to the priesthood, and after ministering at Winnsboro and Abbeville, he became a professor at the University of the South in Sewanee, Tennessee. Eventually, he helped to establish a School of Theology there and served as its second dean until his retirement in 1908. In the early twentieth century, he authored a number of books that gained him international recognition as a theologian.

THE HASKELLS OF ABBEVILLE

Sophia Lovell Cheves Haskell (1809–1881) was the eldest daughter of celebrated South Carolina statesman Langdon Cheves. She married Charles Thomson Haskell (1802–1874) in 1830. The couple first lived at Fort Motte in the midlands district of Orangeburg but later moved into the upcountry, to Abbeville District, where they purchased lands and planted. Sophia and Charles Haskell were the parents of a large family that included seven sons who served in the Confederate army. Two of them, Charles and William, were killed in action, and two others, Alexander and John, were badly wounded but survived the war. The paternal great-grandfather of the Haskell brothers was Colonel William Thomson, a hero of the Revolution. He was one of the officers in command of South Carolinians who repulsed British forces at Breach Inlet near Charleston in 1776.

Mrs. Haskell's niece, Louisa McCord Smythe, characterized her as "dignified, gentle, unassuming, simple, but queenly."[160] William Porcher DuBose, a South Carolinian who served in the Confederate army as an officer and a chaplain, admired the Haskell family and considered his friendship with them one of the great privileges of his life. He especially admired Mrs. Haskell, a person of deep faith. DuBose regarded her as a great woman, describing her in his reminiscences as the "worthy daughter" of her distinguished father and a cultured and accomplished woman who "trained up, in all that adds nobility to noble natures, eight sons, of whom seven served with distinguished gallantry, and two consecrated with their life-blood the cause which they believed to be that of justice, patriotism, and honor."[161]

DuBose compared Mrs. Haskell to the mother of the Gracchi, referring to Cornelia, a noblewoman of ancient Rome. Celebrated as the supreme model of virtuous motherhood, Cornelia educated and raised her two sons, Tiberius and Gaius Gracchus, with a high sense of duty and character. Such women as Cornelia and Mrs. Haskell, wrote DuBose, were "the mothers of distinguished sons who owed a great part of their greatness to the personalities of their mothers."[162]

In his book *Belles, Beaux and Brains of the Sixties*, Thomas Cooper De Leon, a Confederate veteran and author, wrote of Mrs. Haskell:

Mrs. Charles Thomson Haskell…had seven sons in the army around Richmond when I met her…in one of several visits she made to tend their wounds. All of them had been privates in the army before the firing on Fort Sumter. She was ever quiet, but genial; hiding what

suspense and anguish held her; making unknowing, great history for her state and for all time.[163]

A letter that Mrs. Haskell wrote to a friend in Delaware on March 28, 1861, reveals her pride in her sons and the patriotic fervor of South Carolinians just prior to the outbreak of the war:

My dear old friend,

I have been intending to write to you for some time past but have had an unusually large correspondence to keep up and have been twice to Charleston in the last few months. We went there last month with the expectation, almost amounting to certainty, to see the taking of Fort Sumter. Three of our brave boys, our second, third, and fourth, were there. Two privates in our Abbeville Volunteers, the other Charles, an officer in the Regulars of the Provisional Army. I felt if that attack once began, I could hardly hope to see them all come home again, and indeed they are noble boys and hard to part with. Everybody praises them and you must forgive me if I boast a little. I have earned the right by many an anxious hour this winter. When I was busy trimming my trees and pruning my vines, I could not help asking myself, but too often, who will be here when these ripen, and which bright face will be missing at our summer family gathering? And the first one I always thought of was my merry blue eyed boy Alec. He was in no more danger than the others but he seemed to have gone with all the ardour of the days of chivalry to lay down his life for his God, his Country, and his Lady Love. An uncertain vision the last but not less earnestly worshipped. His letters were almost wild with excitement, and all the world seemed brighter and fairer as he seemed to feel he was taking his last look at it, and ending his letter to me he said "whatever may happen my trust is in God. God save our Country! For such a Country and such a people it is easy to die."

I meant to write you a sober, quiet letter. But we have been in a state of singular excitement all this Winter. I have never seen anything like it. There is a steady spirit of firm resolution I could not have imagined. The spirit of '76 could not surpass it...[164]

The son she referred to as "my merry blue eyed boy Alec" was Alexander Cheves Haskell (1839–1910), who would later become colonel of the Seventh South Carolina Cavalry. Thomas Cooper De Leon recounted this young man's engagement and wedding during the war:

His first marriage was one of the most touching romances of the war. Miss Rebecca Singleton was a dainty and lovely, but high-spirited, daughter of that famed old name. In the still hopeful June of 1861 Mrs. Singleton and her daughter were at the hospital in Charlottesville, crowded so that Mrs. Chesnut (as her diary tells) took the young girl for her roommate. "She was the worst in love girl I ever saw," that free chronicler records. Miss Singleton and Captain Haskell were engaged, and he wrote urgently for her consent to marry him at once. All was so uncertain in war, and he wished to have her all his own while he lived. He got leave, came up to the hospital, and the wedding took place amid bright anticipations and showers of April tears. There was no single vacant space in the house, so Mrs. Chesnut gave up her room to the bridal pair. Duty called; the groom hurried back to it the day after the wedding.[165]

Alexander Cheves Haskell and Rebecca "Decca" Singleton were married on September 10, 1861, but their days together as husband and wife were to be brief. De Leon recorded that "one year later the husband was a widower, with only the news of his far-away baby girl to solace the solitude of his tent."[166]

In June 1862, Mary Chesnut recorded Decca's last days and passing in her diary. Before she died, the young Mrs. Haskell told Mrs. Chesnut that she "had had months of perfect happiness."[167]

Alexander Cheves Haskell was wounded four times during the war, most seriously in October 1864, when he was shot in the head. He lost an eye but otherwise made a remarkable recovery and returned to his unit in the Army of Northern Virginia to serve to the end. His daughter, Louise Haskell Daly, wrote a biography of him that included his memoirs and letters entitled *Alexander Cheves Haskell: The Portrait of a Man*. Only about 125 copies were privately printed in 1934, and the author sent one to famous author and historian Douglas Southall Freeman, who is best known for his biographies of Robert E. Lee and George Washington. Freeman considered Haskell's memoirs one of the most important personal narratives of the war and asked Mrs. Daly for permission to include one of his letters in a new book he was working on (*The South to Posterity*, published in 1939). Freeman called a letter Alexander Cheves Haskell had written to his mother in 1863 the noblest and "most beautiful born of war" and held him up, along with such figures as Robert E. Lee and Stonewall Jackson, as one of the highest examples of Southern character.[168]

Freeman also made use of the writings of another Haskell brother, John Cheves Haskell (1841–1906), for his book *Lee's Lieutenants*, characterizing Haskell's war reminiscences as entirely "charming memoirs."[169]

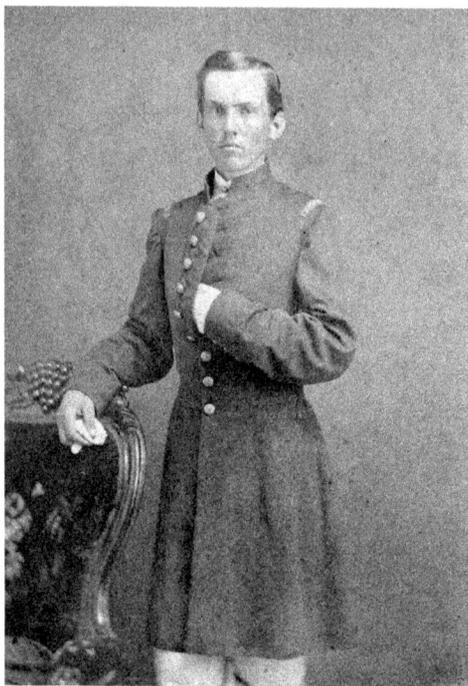

This photograph of John Cheves Haskell was taken after he lost his arm at the Battle of Gaines Mill in Virginia. *From the collections of the South Carolina Historical Society.*

Like his brothers, John C. Haskell grew up on his family plantation in Abbeville District. He was tutored at home until he entered the South Carolina College in Columbia in 1859. In 1861, he enlisted in the Confederate army and was appointed as a junior officer in an artillery company. Eventually, he rose to the rank of colonel. At the Battle of Gaines Mill in June 1862, he lost his arm but went back to full duty late in that same year. In October 1864, he suffered another severe wound but again returned to active service.

John's elder brother, William Thomson Haskell, a captain of Company A of the First South Carolina Volunteers, received a mortal wound while leading his men at Gettysburg in 1863. A few days later, another brother and an uncle died within hours of each other in a battle in Charleston Harbor. William's brother Charles Thomson Haskell died at Morris Island while resisting an enemy attack, and his mother's brother, Langdon Cheves, was killed by one of the first shells thrown into Battery Wagner. This uncle of the Haskell brothers, Captain Langdon Cheves (born in 1814), was the engineer of Battery Wagner. A Confederate battery on James Island was named in his honor.

William Porcher DuBose described how Mrs. Haskell received word of these three terrible losses in the family on the same day: "The same mail brought to Mrs. Haskell the intelligence of the death of Captains Langdon Cheves, Charles T. Haskell, and William T. Haskell, a brother and two sons, one in the vigor of maturity, the others in the prime of youthful manhood."[170]

At about the same time, the grieving father, Charles T. Haskell Sr., received a letter from Lieutenant J. Moultrie Horlbeck, one of his son's fellow officers. It gave details of the death of Charles Jr., whose last thoughts were of his mother.

Battery Wagner, Saturday 11ᵗʰ July
Dear Sir,

I take the liberty of addressing you in relation to your brave & gallant son the late Capt. Charles Haskell. He received orders to report on Monday morning with myself & company to Col. Yates on Morris Island, the duty to storm the battery on Folly Island. After making two unsuccessful attempts he was ordered on Friday morning to repel with his company the advances of the Yankees to Morris Island. After fighting as bravely as man ever fought in the advance the whole time he fell pierced by nine bullets. His last words were "Tell my mother I fell fighting for my country."

I shall endeavour if possible to recover the body and have already spoken to Col. Graham commanding about a flag of truce but have been unable to start on account of the terrific fire from the monitors. I am dear Sir with great respect & sadness your obedt. Servant

> *J. Moultrie Horlbeck*
> *Lt. 1ˢᵗ So Ca Infy.*[171]

William Gilmore Simms, South Carolina's foremost man of letters, composed many fine poems during the war. In one entitled "Fort Wagner," he honored the Confederate soldiers and officers who fought and died at Morris Island in Charleston Harbor, making particular mention of Mrs. Haskell's brother Captain Cheves and her son Charles. "Their memories," wrote Simms, "shall be monuments."

> *A shrine for thee, young Cheves, well devoted,*
> *Most worthy of a great, illustrious sire;*
> *A niche for thee, young Haskell, nobly noted,*
> *When skies and seas around thee shook with fire!*[172]

William Porcher DuBose chronicled the death of Captain William T. Haskell, who was serving in Gregg's Brigade:

> *In 1863, in preparation for the invasion of Pennsylvania, the sharpshooters of the division were organized into a battalion, and Captain Haskell was selected to command it. On the 3ʳᵈ day of July following, at Gettysburg, he fell dead at its head, "while leading his men," says one, "with that serene courage and unselfish devotion which had characterized him through life."*[173]

Edward McCrady Jr., a friend of William T. Haskell, wrote a lengthy letter of condolence to Charles T. Haskell, and excerpts from it illustrate William's character:

My dear Sir,

It has been with the greatest pain that I have learned the deaths of your two sons, Captain Charles T. and William Haskell, and of your relative, Capt. Cheves…Where so many fathers have cause to be proud of their sons they have given to their country, none have more and few such cause as yourself…

With your son Charles who fell so gallantly on Morris Island I was not so well acquainted, but…with William I esteem it one of the greatest privileges of life to have been for the last two years upon the most intimate terms. We met upon the organization of our Regiment in Richmond in the summer of '61. Similar tastes and feelings soon drew us together and in a short time I learned to appreciate his remarkable character, a character the foundation of which was a sincere piety. An esteem for him which soon sprung up strengthened and ripened into a regard such as few men could possibly inspire. Duty was truly the rule of his life…As an officer he had no requirement for his men he did not apply to himself. Their hardships he shared…In battle he only asked his men to follow him…

Comfort and safety seemed in his opinion to have been for others, hardships and dangers for himself. It was one of his most striking traits that hard as was his rule for himself, he had no such measure for others. His character combined all the elements of greatness…We used to call him the "old Roman" but his character was far more sublime for it was that of a Christian…

The Lord who only can assuage such grief as yours may & will I trust give his mother and yourself strength to bear it.

I am dear Sir very truly yours
Edward McCrady, Jr.
Lieut. Col. 1ˢᵗ S. C. V.[174]

Reverend John Bachman, a prominent Lutheran clergyman of Charleston and a relative of the Haskells, also expressed his sympathies and admiration in a letter to Mr. Haskell:

My dear Sir,

With the deepest sympathy for the heavy bereavements which have shrouded your house in sorrow & mourning I wish it were in my power to assuage your griefs...

Few men in our Confederacy have contributed so largely to their country's defense as you have done. You offered up on that altar your own beloved sons. That country is our Mother. Your brave boys voluntarily flew to her rescue & in defense of her honour & her rights they shed their blood & surrendered their lives on the battle field. How noble was the cause in which they were engaged & how honourable their deaths...My good wife & myself often spoke of your large family of sons & could not fail to remark, that we had never met a family of sons of which the parents had such just reasons to be proud. They were well educated, intelligent, devoted to their parents, honourable, respectful, virtuous, a reverential regard to religion & an undying patriotism...They exhibited intelligence, courage & patriotism which was an example & should prove a stimulant to all who are interested in the liberties of their beloved & now bleeding & downtrodden country...[175]

Louisa S. McCord, who had also lost a son in 1863, wrote to Mrs. Haskell:

My Dear Sister,

Until your letter (received last evening) I had heard nothing of our latest sorrow. Our sorrow I say for I claim to halve it with you. Willy & Aleck, since my great agony, have seemed half to belong to me. They could not fill the place of my own lost darling, but they were so kind & so linked with him in my thoughts, that I took them into my heart as something left of him...Falling as he has done, so far away from us, there will perhaps no relic of dear Willy come home to you, & you will, I think, like to know that I have in my possession the sword which he carried through 12 battles. It was brought to me by one Col. McCrady (sent by Willy) only a few weeks since, for me to take care of. I wrote him word that nobody should touch it till he came for it himself. But to you & his Father it now of right, belongs. Should it chance that a watch be sent to you, do not think it a mistake. I lent him the last one used by Cheves, begging him to wear it in the fight and bring it home to me. I would come & see you but would do you harm. I need to be alone a great deal, and cannot always command myself as I should.

With any change I would likely be ill & a burden to you. My girls seem to feel as if their brother was lost a second time. Poor children, these shocks are very trying to them. This fearful war brings to our daughters a sadder fate than to their slaughtered brothers.

Once more dear Sister you know my sympathies are with you all. Would to God, I had anything else to give.

Truly yours & most affectionately,
Louisa S. McCord[176]

The body of William T. Haskell was eventually sent home to Abbeville, and he was buried in the same grave with his brother Charles (who is also memorialized by a marker at Magnolia Cemetery in Charleston).

This drawing depicts the carving on the gravestone of the Haskell brothers in Abbeville. The Latin, from an ode by the Roman poet Horace, can be translated to "It is sweet and fitting to die for the homeland." "Patria," from the Latin word *pater*, meaning "father," could literally mean one's father's lands—that is, one's home. *Drawing courtesy of James E. Kibler.*

William Porcher DuBose described William's return:

In November, 1866, the remains of William Thomson Haskell were raised from the field of Gettysburg by the hands of his comrades and brought to his native town. At the depot they were met by the survivors of the old company with which he had originally entered the service, and escorted to the Episcopal Church, where, with solemn services and amid deep emotion, they were interred in the adjacent cemetery.[177]

The ledger stone marking the grave of the two brothers is adorned with two linked laurel wreaths and a pair of crossed swords.

Survived by six sons and a daughter, Sophia Haskell died on July 30, 1881, and was buried in the cemetery of Trinity Episcopal Church in Abbeville. Inside the church, there is a handsome stone plaque that memorializes Mr. and Mrs. Haskell and their children.

ROSA WITTE'S WARTIME REMINISCENCES

Rosa Glen Reeves Witte (1842–1931) was the daughter of Matthew Sully Reeves, a Charleston professor of music, and Ellen Jackson Bounetheau Reeves. Mr. Reeves died on August 11, 1862, and about a year later, his widow and children fled their home in Charleston because of the bombardment of the city that began in August 1863. In her reminiscences, Rosa described how her family was forced to take refuge in Orangeburg, South Carolina:

Suddenly one day in August, long before day, early as day comes this time of the year, we were startled and terrified out of sleep, as a hurling, hissing, crashing sound, worse than thunder at its worst, and the terrible truth forced itself upon us that they were bombarding our City. I thought at first that a meteor had burst over us, for the first shell passed above us and exploded on the next block. A boat with a flag of truce was sent to the fleet to know whether the City was to be destroyed with its women and children. "We will give you two days to remove your women and children," was the reply, "On Monday Charleston is to be bombarded in earnest."

Oh what a time of stress and storm! Forty eight hours for helpless women and children to find refuge among strangers, to leave their homes alone, for

husbands and fathers were either away in Camp, or in the service at home, and could not leave.

To take anything but a little clothing was out of the question. The railroads had enough to do to take the people, who knew not where they could find shelter for themselves.

My mother decided to join some friends who were going to refugee in Orangeburg. Never can I forget that night at the South Carolina Railroad depot. The scene must have borne a strange resemblance to one which had been enacted nearly two hundred years ago, when our Huguenot forefathers left their homes to seek shelter in a foreign land, save for this difference, that then fathers and husbands had their families in care. The night of our flight was hot and sultry, we were so huddled together that it was literally stifling. Then the leave-taking. I saw strong men, pale with grief, straining weeping wives and children to their hearts, and fairly totter from the cars in agony, not knowing what their fate might be, or if that farewell might not be the last in the world.

At midnight or perhaps later, we arrived in Orangeburg. Such a mournful, weary band of people left the depot, to wander about in the darkness, seeking shelter. From the door they heard repeatedly, "No room, no room," till finally at about a mile uptown at what was called a hotel we were allowed to enter. Seats or beds were out of the question, so into one room we crowded, and sat until daylight, finding only such support as we could get from leaning against each other.

As soon as we could see to walk around we went into the yard and finding a well full of water performed such ablutions as we could, without the luxuries of basins or towels; then we were told we might have breakfast. A sorry breakfast table indeed, and the refugees looked more dead than alive; even the fun loving boys and girls quailed at the sight. But we were hungry and glad to get anything, so I helped myself to a waffle, and as I cut it, horrors! A large roach was snugly embedded therein. At that moment, directly opposite, I saw a poor, worn out refugee mother fall over with a wild shriek into a fainting spell; all of which frightened me to such a degree that I sprang up and rushed from the room as fast as my feet could carry me.

Later my mother succeeded in obtaining an attic room, where she and her six children lived until the townspeople recovering a little from the shock of having their village so inundated by strangers, began opening and renting houses to them; and so afterwards we became more comfortable...

And so we lived up there in a world of our own. But oh the hunger and hardships of those days...At times, failing to get provisions in the village it

would be necessary to forage around in the country. There was a good man, a Mr. Ahrens, living near us, who was always ready to rent his horse and buggy to refugees at a nominal rate, no doubt as a kindness. He it is who served hot coffee to my mother and her children during Sherman's raid in 1865, when we sat at the dead of night, the ground frozen under our feet, in front of our burning house, without shelter and with little covering...

As time wore on our privations increased, but in spite of everything we had good times too. The soldiers came home on furlough or sick leave, and we felt it our duty to make their stay a happy one. There were dances, card parties, theatricals, concerts—every girl had a sweetheart, engagements were made, too often to be broken by death; when farewells were said, too often it was forever. These parties were cold water gatherings, or as they were called, "Starvation Parties."

The year '64 dragged on its cruel way, and the call came for more soldiers. In Virginia and in the West battle after battle had been fought, and our brave fellows were falling like leaves in Autumn. Then came the time for boys of sixteen to leave their schools and swell the ranks. Poor children. Many of them fell by the wayside, unaccustomed to the discipline and hardships of camp life. My brother John who was attending Dr. Bruns' school at the time, shouldered his musket and fell into the ranks with the others, and before the end of the struggle became ill with diphtheria and then with typhoid fever.

1865 dawned for us with the deepest gloom. Sherman was marching through the southern country to the coast and making war upon women and children, driving them from their homes, setting fire to their houses even before they were well out of them, destroying crops, devastating and laying waste [to] everything that came in his way, tearing up railroad tracks, burning cars and depots, in fact leaving nothing behind him but standing chimneys and smoking ruins. As terrible as that march was in other states, we were told that South Carolina could expect no mercy. At this time, Mother sent me to Augusta in care of a friend, to get shoes and much needed articles for the children while the Confederate money could still be used...

We left Orangeburg to return in three days, and little did I think I would never again see our home, or any of the others, for before I could return we were entirely cut off from any communication with Orangeburg. Ten weeks later, a merchant of that place, Mr. Neuffer, who travelled across the country in his buggy to buy supplies for suffering people, kindly took me back with him...[178]

Some of Rosa's story is told in letters that were written to her by family members while she was away in Augusta, Georgia. Her sister Lottie (Charlotte) S. Reeves described the family's experiences when the army of General William T. Sherman captured, occupied and burned the town of Orangeburg:

Orangeburg, 25 Jan. 1865
My Dear Rosa,

We can well imagine how anxious you must be separated from us, and ignorant of our fate. We have however survived the visit of our [dear?] friends, and dear we did find them in one sense of the word. You may thank your stars that you were not here, for you would not be as well off as you are now. For a week before the Yanks did come the quiet people of Orangeburg were thrown into a state of consternation at their approach. Sunday the fifth, there was a perfect stampede. Half of the village left, or spent half of the day at the depot. The regular train did not arrive until five in the afternoon, meanwhile a special train was chartered and bore away the affrighted crowd...

On Saturday we were startled by hearing the booming of cannon, and Thomas came running in to tell us that the enemy had attacked our forces at the bridge. Just think of that innocent old bridge over which we had strolled so often, to be made famous in history as the scene of a conflict...

They commenced firing at eleven in the morning, and the skirmishing was furious all day. Two of our men were killed, one was buried in the Episcopal churchyard, and the other lay on the causeway until Tuesday. Saturday we did not go to bed at all, our men evacuated the town at midnight, they moved as though shod with velvet. There were only two hundred of them, and before they left the village they received orders to hold the place, they returned to the breastworks and were reinforced by four hundred men. At intervals during the night reports of cannon could be heard, and at daybreak the firing began vigorously. At twelve o'clock Fannie and myself were looking over the fence opposite the hotel when we saw the enemy crossing the field, and our men retreating. It is certainly miraculous that they were not all captured. We all gathered on the hotel piazza not knowing what to do, when we saw soldiers forming a line of battle just in front of the gate and General Taliaferro rode in the yard and advised us to leave as there would be skirmishing along the front of the house and we would be in danger from bullets...Fannie, Julia and I intended going to Gen. Stephenson's office at the depot to ask what we should do, but met three of his staff who advised us to go to the Orphan House.

At last we all got out of the house and made rapid tracks for the depot. It is truly ludicrous to think of now, but at the time it was anything but a laughing matter. At the last moment I sent all of my money to Sister in Columbia by Mr. Bell of the General's staff. Our men were now retreating to the depot at double quick, and the enemy in pursuit. It was truly sad to see our gallant boys retreat, but it was an unavoidable necessity. The only wonder was that a small force of six hundred men could oppose for such a length of time, fourteen thousand, but if we had had half that number they never would have entered the place, and if the bridge were the only way of crossing, they certainly would have been repulsed. As I told you, we went to the Orphan House, and I wish you could have seen the Yankee army as they entered the yard. I never saw such a multitude in my life. It was perfect folly for our men to oppose them…

Mother commenced to think then of getting home. We advised her to ask for a guard, but Thomas and she passed the whole army alone. While she was gone, Miss Irving escorted Sherman over the house. He is a tall, thin, stern looking man, I should judge about fifty. He was accompanied by a young captain, very handsome man, who spoke to me of the general. I told him I had quite a curiosity to see the redoubtable general. I said it with all the sarcasm I was capable, he laughed and inquired if I did not think him very terrible. I told him I had seen men before whom I considered quite as terrible, he said he supposed so, and walked off. I am filling my paper with all these trivialities, and still have the most important part of the performance to relate, in fact the grand tragedy. Mother stayed so long that Fannie and I became quite impatient, and a lieutenant hearing that we wished to go home offered his services to escort us, which were, of course, accepted. We got as far as Champney's when we saw the upper part of the village in flames and were certain that the hotel was gone. The other girls commenced to cry, but I did not shed a tear. I was determined that I would not let the Yankees see how much I felt. We had to go all the way around Mr. John Rowe's field to get home, when we got there what a scene of confusion! The house had not yet caught, but it was in danger momentarily. The soldiers were helping to take furniture out of the house. There was so much confusion that the people did not know what to do. Mother said when she reached home they had ransacked the house, drawers were pulled out and clothing scattered all over the floor. Two were burnt with all of their contents. Whatever was taken out was put in the field (for we did not know what house was safe), and was stolen. Mother actually saw one man carrying off some of her things. She told him they were hers. "Oh,"

said he, "they are mine now." Well, all the furniture was burnt except the piano, the sewing machine, a few chairs, three of which were minus a leg each, one bed, a pair of blankets and a few sheets. I lost everything. I am sorry to say, and you lost everything that you left at home. Even our desks are gone. I saw them broken open and lying on the ground. Everything gone out of them. It is a pity you did not take your things with you…Johnnie's box was saved but some of his clothes were stolen…

It was a lamentable thing to see the hotel enveloped in flames, and all of us in the street. Mother was in the house when it caught, and had to be sent for a dozen times. I walked through seas of fire, when the sparks were falling like hail around me…

Imagine us homeless and surrounded by the enemy; I think at one time fifty must have been around me. I was in the center talking to the crowd, and did not hesitate to express my opinion. They seemed to be very much amused at my spunk, as they called it. I hope that you may not be visited by them for they are worse than ten plagues…

I must stop now. Good night. Write soon.

Yours with love, Lottie S.R. [179]

Rosa continued with an account and letters of her married sister Mary Ellen Reeves Harper in Columbia, a city that was one of Sherman's next targets in his army's destructive march across the state. Mrs. Harper was employed by the Confederate Treasury Bureau there.

At last news came from our sister in Columbia, through a personal letter. She was a signer in the Bureau, and when Columbia was taken the Bureau left to avoid capture. The family with whom she boarded informed the enemy that was one of the Bureau and showed them her room. She had already left the house to secure shelter for herself and her baby at the home of friends, leaving everything, including valuables, in care of a faithful slave, Maum Charlotte. She locked the trunk and then the door at which she stood guard. The Yankees ordered the door to be opened. "My mistress has given everything in this house to me," she answered, "and if you go in it will be over my dead body." The soldiers looked at her for a moment, and then one of them said, "Well Auntie that's all right, if the things are yours." As that was one of the few houses not destroyed, when the reign of terror was over in Columbia, my sister Missie recovered the trunks intact, as Maum Charlotte had carefully packed everything that had been left to her care…

The following letter came to me from Columbia, some days after Sherman's raid, which relieved our anxiety as to the personal safety of our relatives there, but confirm[ed] the gloomy reports which had been flying around the country.

Columbia, Feb. 24th, 1865
Dear Rosa,

Have just heard of some gentlemen who are going to start on foot for Augusta, so I take the opportunity of letting you know that I am still in the land of the living. You have heard of course that Columbia has been laid in ashes. I cannot describe the desolation and distress that has befallen this once beautiful city. On last Thursday the enemy shelled us all day long, and on Friday at eleven o'clock, they took possession of the city. Up to half past ten the citizens believed that the city would be defended and held. They came in with their bands playing and colors flying, and behaved very quietly and we hoped they would spare us, but by dark in the evening they began their fiendish work. I don't think there are fifty houses left. They destroyed everything they could lay their hands on. There are hundreds this day who do not have a change of clothing and not a mouthful to eat. You could not believe unless you were here to see the distress around us. I am staying with the O's. Mr. O says I must remain with them as long as they are here. None of us can remain here, so as soon as there is any communication, we shall have to find a home elsewhere.

Their home was set on fire four times, and it is only through the faithfulness of their servants that we have a roof over our heads this day. All of our clothes and bedding were moved into the back lot, and there we sat the enduring night, in danger of being smothered by the flames and smoke around us. At one time I took Carrie and went into Mr. T's house which was on the next square from Mr. O's and a half dozen Yankees came in there, cursed me and ordered me out of the house. You can imagine my terror. That was the first time I shed a tear. I took Carrie in my arms, rushed out of the house, followed by dozens of them...

There is one thing certain. I shall always try to keep in the rear of the Yankee army. I never wish to be where there is a possible chance of their coming again. They told me if they ever come through Columbia again they would spare neither women nor children...

The Yankees stayed here three days. They came on Friday and left on Monday...

Mary E.H.

Columbia, March 18, 1865
My Dear Rosa,

I left Mrs. Palmer's on Thursday, Feb. 16th, the day on which the enemy shelled us. I had packed up everything the day before, intending to go with the Department, but fortunately I was left…That night I sent for one of my trunks, determining to remain home with them. On Friday morning we were told that Cheatham's Division had arrived and that the City would be defended at all hazards. At ten o'clock we found out to the contrary, all the commissary stores were broken open, and the citizens were allowed to take what they please. The negroes are, I assure you, better off today than the white persons here.

At eleven o'clock the enemy marched into the city, flags flying, and bands of music playing. They first hoisted their flags on the various buildings. On Main Street they behaved shamefully, they got drunk and opened every place, but by us they were very orderly. Mr. O got a guard less than an hour after they took possession of the City, and he did his duty tolerably well. A whole regiment camped in Trinity churchyard opposite us. We began to believe the devil was not as bad as he was painted, and began to congratulate ourselves that we were going to fare very well, but alas, by half past six in the evening, we noticed bright fires in different places in the City, and we were told by our guard that they were camp fires, but we soon found out that the City had been fired. Words are inadequate to express our terror. We could see them putting the torch to the different houses around us. We moved every trunk, carpet, bedding and such things to the back lot, and there we remained all night surrounded by the blue devils, cursing and swearing, and trying to break open our trunks before our very eyes.

At one time in the night we got so cold and the wind was blowing as though heaven and earth were coming together, they persuaded me to take Carrie and go into Mr. T's house around the corner. I did so, and a little while after six of the fiends rushed in, cursing Mrs. T and myself and ordering us out of the house. I took the child in my arms and rushed out, so terrified I actually shrieked aloud. We had not gotten out of the house before we saw flames issuing forth. Mr. T ran back to get his daughter's portrait, and one of the soldiers was seated at the piano playing "Home, Sweet Home." Another came to Mr. T and told him to take off a ring which he wore. Mr. T told him he could not for the flesh had grown over it. "Oh," he answered, "I'll fix that." And actually taking a knife from his pocket, he was going to cut the finger off, in order to get the ring.

Mr. O's house was set on fire four times and was only saved through his own watchfulness together with his servants'. If only you knew the misery and sorrow among thousands here. I have much more to tell you when we meet...Mary E.H.[180]

THE WARTIME DESTRUCTION OF CHURCHES IN SOUTH CAROLINA

During the war, many religious denominations suffered property losses in the state. In 1868, the Protestant Episcopal Diocese of South Carolina published a report of a committee appointed to investigate the destruction of its church buildings in the state. The following excerpts will give an idea of the extent of the damages, beginning with the Episcopal churches in Charleston:

ST. MICHAEL'S CHURCH, the most Southern Episcopal Church in the city, was exposed to peculiar danger. For a year and a half its beautiful spire was a target for [Federal] artillery. The public buildings around were torn by shells aimed at it. The grave yard was ploughed, and its monuments scarred by the balls so remorselessly rained upon it. But the lofty spire still lifts up its head, a beacon to the homeward bound mariner. Several shells penetrated the Church, destroying portions of the interior. The roof, pews and floor suffered from the dangerous missiles. One struck the centre of the chancel wall and burst just within, tearing in pieces the carved panels of English oak, with its exquisite paintings, and massive rails. Its fine organ, the gift of our English ancestors more than a century since, was removed to a place of safety, and has been restored to the Church...[181]

ST. PHILIP'S CHURCH suffered more than St. Michael's, or any other in the city. The marks of twelve shells were visible, which had penetrated the roof and walls. The costly organ was irreparably damaged...[182]

GRACE CHURCH was struck by a single shell, but that proved a destructive one. It crushed one of the central columns and cracked the superincumbent walls up to the roof, tore away twelve pews, and cut the interior in many places...[183]

ST. LUKE AND ST. STEPHEN'S also received damage from shells in roof and walls...[184]

GRACE CHURCH, SULLIVAN'S ISLAND.—This was a brick building...When the United States forces established their batteries on

Morris Island, the Church then came in reach of their shells, which riddled roof and floor, and consumed the wood work...[185]

The report continued with descriptions of damages to churches elsewhere in the state:

CHRIST CHURCH, COLUMBIA, shared the same fate of that beautiful city when burnt by General Sherman's army in February, 1865. With the exception of its elder sister in that city, it was the largest and handsomest Church in the diocese, outside of Charleston...The Church, with its organ, carpet, books and all that it contained, was destroyed in that fearful night. The loss to the congregation amounted to $30,000...[186]

TRINITY CHURCH, COLUMBIA, suffered the loss of its picturesque parsonage, which was burnt, as well as the Sunday School house, with their contents, including the records of the Parish from its organization...The communion plate [silver], a valuable set, was forcibly taken from the Rector, by a band of soldiers, as he was endeavoring to carry it from his burning house to a place of safety...[187]

ST. JOHN'S CHURCH, WINNSBORO.—This Church was wantonly burnt by Sherman's troops, on their march through Winnsboro. The public square was destroyed, but the Church was not touched by that fire. It was on the outskirts of the town in a large lot, and was deliberately set on fire by the soldiers, after the central square was consumed. The organ, furniture, books, and all the Church property perished.[188]

SHELDON CHURCH, PRINCE WILLIAMS' PARISH.—It has been the fate of this venerable Church to pass through two revolutions, and to experience the same fortune in each. It was burnt "by the British in 1780, on their march from Savannah to Charleston," and it was burnt again by the United States army on their march from Savannah to Charleston in 1865. It had previously been stripped of pews and furniture by the negroes. All that was combustible was consumed, except the roof, which was above the reach of the fire; and its massive walls survive the last as they did the former conflagration.[189]

Because of a letter that has come to light in recent years written by Milton M. Leverett, the son of the former rector of Sheldon, it has been suggested that Federal forces did not burn Sheldon Church. Writing to his mother on February 3, 1866, he reported that "Sheldon Church is not burnt down. It

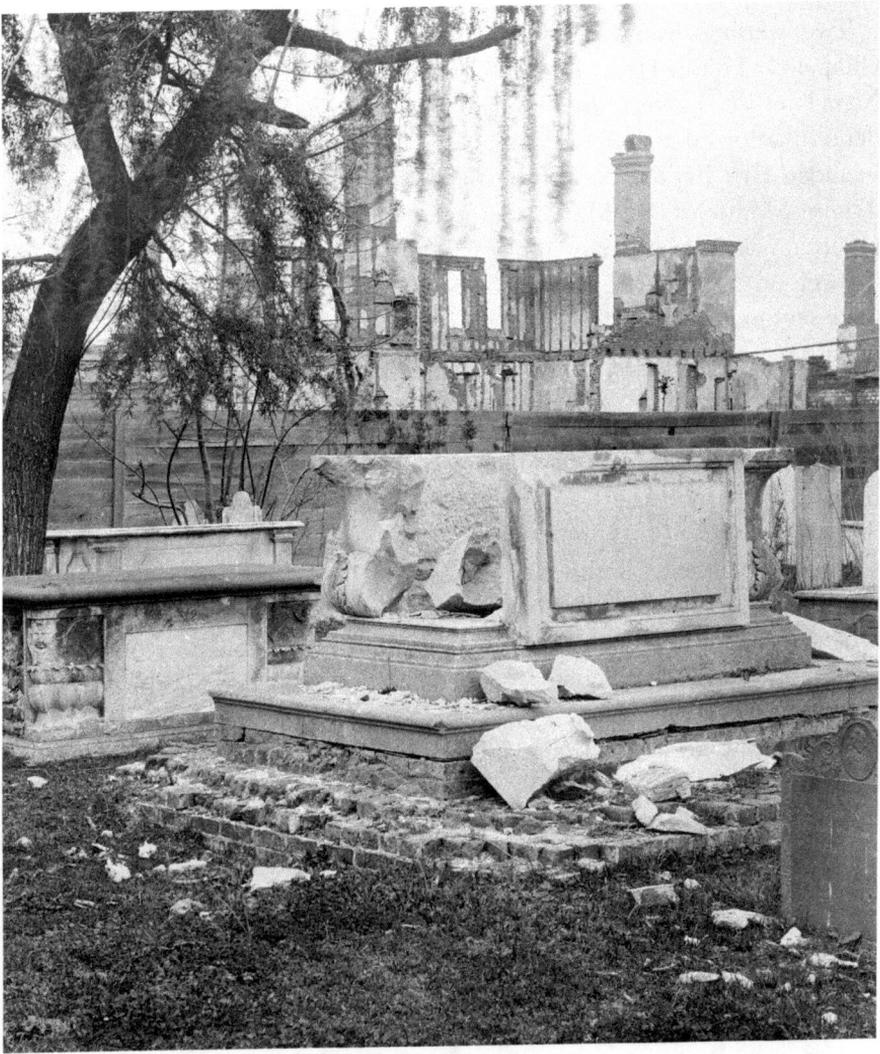

A photograph taken in 1865 shows the damage done to the cemetery of the Circular Church in Charleston by the Federal shelling. *Library of Congress.*

has been torn up inside somewhat but could be repaired."[190] This statement, however, does not necessarily contradict the committee report published in 1868, which stated that "all that was combustible was consumed, except the roof." The interior of the building was likely burned, but without destroying the building's "massive walls." The church was never rebuilt, and only its picturesque ruins remain.

Two sterling-silver Eucharistic chalices belonging to Zion (Episcopal) Chapel on Hilton Head Island were stolen during the war and recovered years later in a pawnshop in Philadelphia. In Charleston, churches of other denominations that suffered damage from the relentless shelling of the city included First Baptist, New Tabernacle Fourth Baptist, St. John's Lutheran, Trinity Methodist, St. Mary's Catholic Church and the French Huguenot Church. Like a number of other Charleston congregations, the Unitarian Church on Archdale Street lost its records and some furnishings when they were sent to Columbia for safekeeping and burned there in 1865.

Father Jeremiah J. O'Connell, a Catholic priest who was in Columbia at the time of its destruction, recorded that "Sherman led his army without remorse through the [state], spreading ruin and desolation on all sides; and in the conflagration of Columbia, destroyed St. Mary's College, the Sisters' house, and the Ursuline Convent…throwing the inmates out into the flames."[191]

Jewish synagogues in the state did not escape damage and loss during the war. The congregation of Beth Elohim at 90 Hasell Street in Charleston sent its organ, chandelier and other precious possessions to Columbia for safekeeping, and most were lost when that city was burned in February 1865. Isaac Leeser, a prominent Jewish rabbi who visited Charleston in 1866, reported that he found the synagogue of Shearith Israel on Wentworth Street in Charleston "so greatly injured during the war, as almost to render it useless as a place of worship."[192] The Beth Elohim building, he added, "was also much disfigured by the explosion of shells fired indiscriminately into Charleston during the protracted siege it underwent, and, by being so long closed, it suffered likewise by natural dilapidation."[193] When he went into the Beth Elohim synagogue in June 1866, he noted "the unwashed floor, many panes of glass broken, the ceiling crushed in many places by the explosion of shells that penetrated the roof."[194]

CRUEL DAYS: THE PILLAGE AND BURNING OF MIDDLETON PLACE

In his description of the Ashley River region west of Charleston, historian Henry A.M. Smith noted that the soil along the river was not very fertile but that "accessibility by water" from Charleston made its settlement desirable. And in time, many of the wealthier inhabitants of the Lowcountry "made

their seats and residences on the Ashley River."[195] There were a number of such properties stretching along both sides of the river, and though not all were as spectacular as Middleton Place (some having fallen into disuse by the time of the war), many of the residences survived until 1865, when Federal troops wrought widespread pillage and destruction in the area. The house at Magnolia Plantation, which, like Middleton Place, was known for its magnificent gardens, was also looted and burned, as were the houses at Oak Forest, Pierponts, The Oaks, Runnymede and other plantations. One of the few plantation residences to survive the ravages of 1865 was the fine mansion at Drayton Hall.

Located on the southwest side of the Ashley River about fifteen miles from Charleston, Middleton Place was established by Henry Middleton (1717–1784) in 1741. The property was subsequently owned by his son Arthur Middleton (a signer of the Declaration of Independence), his grandson Henry Middleton and his great-grandson Williams Middleton (1809–1883).

During the American Revolution, the house at Middleton Place suffered serious damage by British troops, but for the most part the gardens survived.

This photograph shows the beautiful grounds of Middleton Place looking south toward the Ashley River. *Library of Congress.*

In an article published in *The Century* magazine in 1910, author and gardening expert Frances Duncan wrote, "To this day the lines of the original gardens have been kept, and Middleton Place is essentially as it was in 1750."[196] Its gardens, Duncan noted, were "on a splendid scale," featuring abundant azaleas, shaded walks, formal flower gardens, grand oak trees and a terraced bank leading down to the Ashley River.[197]

In February 1865, after all the Confederate troops evacuated Charleston, Federal forces moved in, occupied the city and conducted raids in the surrounding areas, including the Ashley River region. Henry A.M. Smith recorded, "Many if not most of the residences survived until the war of 1860–1865—when they were burned and destroyed by predatory bands of the invading Federal army; but three of any note being spared as far as the writer knows viz: 'Archdale' and 'Jenys' on the north side, and Drayton Hall on the south side."[198]

The house at Middleton Place, which, according to Frances Duncan, was built in the style of an English country mansion, or manor house, was largely destroyed by Federal troops: "The manor-house was of brick and Jacobean in type, a main house, flanked by two corresponding wings. This, like every other building on the place, was destroyed in 1865. One wing only was left standing and this, rebuilt, makes the present house."[199]

The surviving records of Middleton Place show that water buffalo, imported from Constantinople, were used as draft animals on the plantation before the war. At the time of its destruction and pillage in February 1865, soldiers of the Fifty-sixth New York Infantry Regiment slaughtered and ate some of these animals. The others were driven off, and three were taken to the Central Park Zoo in New York.

Nathaniel Russell Middleton, the cousin of the owner, Williams Middleton, was an eyewitness to the pillage and destruction of the beautiful estate. Henry A.M. Smith told his story:

After the death of the Honourable Henry Middleton in 1846 the property passed under his will to his son the late Williams Middleton, Esq. Mr. Williams Middleton was as devoted to the Place as his father and grandfather had been. His energy was untiring in the extension and care of the garden and to him is due the magnificent lines of the Indian Azalea which when in blossom made such a crown of coloring over the terraces. But cruel days were in store for Middleton Place. In February 1865 a raiding party of a merciless enemy as savage in his treatment of inanimate works of beauty and art as the modern Hun in Belgium, occupied Middleton Place. On the day of their

arrival the late Mr. Nathaniel Russell Middleton, the then elderly President of the Charleston College, a cousin of Mr. Williams Middleton, rode over to Middleton Place to visit a sick slave there. He was unarmed save for an umbrella. Being very near-sighted he was not even aware of the presence of the enemy until near the Mansion house, when he was suddenly confronted by a file of negro soldiers, of a negro regiment from the north. He was forced to dismount and one of them seizing his umbrella, struck him, inflicting a deep gash near his temple. He was then marched before the white officers and ordered out to execution which he faced with unmoved composure. He was brought back and after some discussion again ordered to be shot, and brought back and a third time ordered to face the firing squad, when the sick slave he had been on his way to visit, got up from his sick bed and with some of the other slaves on the place implored his release, insisting that he was not the proprietor of the place and expressing their devotion to him. Thereupon after some delay he was roughly ordered to go but his horse was kept. Whilst he was there the houses were being pillaged of all their contents, and the ground was strewn with the library and the pictures and objects of art in the house. Before he left all the buildings were in flames, and every building on the place was ultimately destroyed. Many of the pictures however were taken from the house before it was consumed and carried off. The family vault was broken into, the caskets rifled, including that of Governor Middleton, and the decayed remnants of humanity cast outside.[200]

Dr. Henry Orlando Marcy, a surgeon serving with the Federal forces that invaded the Charleston area, kept a diary of his activities and observations in 1865, in which he describes the destruction of a number of plantations and towns in the Lowcountry, including Grahamville and Middleton Place. Before the house at Middleton Place was burned, Marcy went inside and looked around. In his diary, he recorded that there was a great deal of fine art in the house, including hundreds of paintings, as well as a large library he described as the largest and "most select" he had ever seen.[201] While touring the house, Marcy "selected" a few of the smaller paintings and took them with him. Before leaving, the doctor begged the officer in charge not to burn the library, but his pleas went unheeded, and the house and books were consigned to the flames. Marcy also reported in his diary that the "colored people" at Middleton Place "were robbed indiscriminantly [*sic*]" by the soldiers.[202]

Dr. Marcy later returned to Middleton Place, where he discovered some belongings the owner had concealed in the woods. In anticipation of the arrival of the enemy, owner Williams Middleton had boxed up and hidden

a number of books, paintings and other valuables at various places on the property. When he returned to Middleton Place after the war, some of his former slaves told him that Dr. Marcy had carried off a boatload of the concealed goods. In 1866, hoping to recover some of these possessions, one of Williams Middleton's cousins visited Dr. Marcy at his home in Cambridge, Massachusetts, and there she saw two paintings that had been at Middleton Place. After her visit, Dr. Marcy wrote to Middleton, replying rather disingenuously that he had not thought the paintings belonged to Mr. Middleton because he had "been informed" that the collections at Middleton Place had been destroyed and that it "was reported that the destruction was complete."[203] According to his diary, Marcy had seen the destruction with his own eyes when he returned to Middleton Place the day after it was burned. In another diary entry, the doctor also noted that he carried off a large quantity of books he had found hidden in the woods.

In a subsequent communication, Dr. Marcy acknowledged that he was indeed in possession of at least two paintings belonging to Williams Middleton, who had described the works of art exactly in his letter. Claiming that he had purchased them for ten dollars each and had both of them repaired and framed, Marcy offered to sell them back to the original owner for the cost of his expenses. Williams Middleton continued to correspond with Henry Orlando Marcy over the following years, and in the 1870s, some of the artwork taken by the doctor was at last returned to Middleton Place.

In the 1930s, the owners of Middleton Place hired an architect named L. Bancel LaFarge to restore some of its former glory by re-creating some of the buildings that had been wantonly destroyed in 1865. With a careful eye to history and heritage, he designed and built handsome stable yards and a guest residence in a style of the nineteenth century. About a decade later, during World War II, LaFarge would become one of the celebrated "Monuments Men" who helped to save countless objects of artistic and cultural value that had been looted in Europe by the Nazis.

Writing just after the first world war in 1919, historian Henry A.M. Smith noted of Middleton Place's fate:

> *The whole scene of destruction was as complete as that of the French Chateaux rifled, despoiled, and burnt by the German army in Northern France…it would be hypocritical to pretend at this time not to be conscious of the inconsistency which now condemns and execrates the Germans for doing in France what it applauded in 1865 the armies of Sherman, Potter, and Miles for doing in South Carolina.*[204]

NOTES

CHAPTER 1

1. Crawford, *Genesis of the Civil War*, 52–55.
2. May, *South Carolina Secedes*, 82–90.
3. Ibid., 85.
4. Ibid., 79–80.
5. Ibid.
6. In his book *When in the Course of Human Events*, historian Charles Adams argued that slavery was in no jeopardy in 1860 and that Southern politicians merely used fears about abolition and slave insurrections as a political ploy to galvanize support among the Southern people for secession and independence.
7. *Richmond Enquirer*, September 28, 1860.
8. Grinspan, "Young Men for War," 358.
9. Ibid., 374.
10. Prentiss, *A Sermon*, 16.
11. May, *South Carolina Secedes*, 90.
12. A protectionist tariff was passed by the U.S. Congress in March 1861. A report published by the Confederate Committee on Foreign Affairs in May 1861 called it "robbery" and stated that "the reign of sectional oppression and tyranny, anticipated by the seceding states, is fully inaugurated at Washington by the passage of this act."
13. *Confederate Military History*, 8.
14. Davis, *Rise and Fall of the Confederate Government*, 187.
15. Isaac W. Hayne, letter to James Buchanan, January 31, 1861, SCHS.
16. Joseph Holt, letter to Isaac W. Hayne, February 6, 1861, SCHS.
17. Isaac W. Hayne, letter to James Buchanan, February 7, 1861, SCHS.

18. Davis, *Rise and Fall of the Confederate Government*, 187.
19. Crawford, *Genesis of the Civil War*, 129.
20. Joseph Holt, letter to Isaac W. Hayne, January 22, 1861, SCHS.
21. *War of the Rebellion*, Series I, Vol. 1, Part 1, 187.
22. Dwyer, *War Between the States*, 188. Lincoln also supported a little-known proposed constitutional amendment that would have prohibited the Federal government from ever interfering with slavery in states where it already legally existed. This was the Corwin Amendment, and after its passage by the Republican-controlled Congress, the ratification process began in the state legislatures. Ohio was the first to ratify it, but the process was never completed due to the advent of the war.
23. Denson, "Lincoln and the First Shot," 243.
24. Doubleday, *Reminiscences*, 133.
25. Scharf, *History of the Confederate Navy*, 18.
26. Denson, "Lincoln and the First Shot," 262.
27. *War of the Rebellion*, Series 1, Vol. I, Part 1, 289.
28. Ibid.
29. Denson, "Lincoln and the First Shot," 262.
30. Davis, *Rise and Fall of the Confederate Government*, 248.
31. Ibid., 252.
32. Tilley, *Lincoln Takes Command*, 252.
33. Ibid., 249.
34. Tilley, *Lincoln Takes Command*, 252.
35. Denson, *Century of War*, 74.
36. Ibid., 73.
37. Chester, "Inside Sumter," 68.
38. *War of the Rebellion*, Series 1, Vol. 1, Part 5, 486.

CHAPTER 2

39. DeTreville, *Sea Island Lands*, 2.
40. Hays, *Short Historical Sketch*, 9.
41. DeTreville, *Sea Island Lands*, 3.
42. Ibid.
43. Davis, *History of the 104th Pennsylvania Regiment*, 184.
44. *War of the Rebellion*, Series I, Vol. VI, Part 1, 187.
45. Smith, "Northern Libraries and the Confederacy," 69.
46. Helsley, *Beaufort*, 117–18.
47. Dabbs, *Sea Island Diary*, 124.
48. *War of the Rebellion*, Series III, Vol. 2, 54.
49. Ibid., 52–53.
50. Ibid., 57.
51. Rose, *Rehearsal for Reconstruction*, 329.
52. *War of the Rebellion*, Series III, Vol. 4, 1022, 1028–29.
53. Hawks, *A Woman's Civil War*, 34.

54. Ibid.
55. Wiley, *Life of Billy Yank*, 114.
56. Hawks, *A Woman's Civil War*, 34.
57. Salley, *Minutes of the Vestry*, 3.
58. Baldwin, *History of Spring Island*, 59.
59. *Official Records of the Union and Confederate Navies*, Series I, Vol. 14, 237.
60. Edward H. Mellichamp Papers, SCHS.
61. Albergotti, *Abigail's Story*, 239–40.
62. Ibid., 240.
63. Records of the crimes and executions of Grippen and Redding can be found in the "List of U.S. Soldiers Executed by the United States Military Authorities During the War" at the National Archives. The spelling of their names varies slightly.
64. Thomas J. Goodwyn, letter to Governor Magrath, March 2, 1865, SCDAH.
65. Carroll, *Report of the Committee*, 3.
66. Ibid., 9–12.
67. Ibid., 8.
68. Ibid., 9–12.
69. Ibid., 18.
70. Ibid., 12–13.
71. Ibid., 15.
72. Ibid., 15–16.
73. Ibid., 16.
74. Harriott Ravenel Horry, letter, February 24, 1865, SCHS.
75. Carroll, *Report of the Committee*, 18.
76. Elmore, *Carnival of Destruction*, 428.
77. Pepper, *Personal Recollections*, 311.

CHAPTER 3

78. Henry W. Feilden, letter to Julia McCord, April 20, 1864, SCHS.
79. Henry W. Feilden, letter to Julia McCord, April 29, 1864, SCHS.
80. Henry W. Feilden, letter to Julia McCord, April 30, 1864, SCHS.
81. Henry W. Feilden, letter to Julia McCord, May 6, 1864, SCHS.
82. Henry W. Feilden, letter to Julia McCord, May 23, 1864, SCHS.
83. Henry W. Feilden, letter to Julia McCord, May 28, 1864, SCHS.
84. General Samuel Jones, letter to General Samuel Cooper, July 20, 1864, SCHS.
85. Henry W. Feilden, letter to Julia McCord, July 11, 1864, SCHS.
86. Henry W. Feilden, letter to Julia McCord Feilden, December 21, 1864, SCHS.
87. Henry W. Feilden, letter to Julia McCord Feilden, January 5, 1865, SCHS.
88. Henry W. Feilden, letter to Julia McCord Feilden, February 28, 1865, SCHS.
89. Henry W. Feilden, letter to Julia McCord Feilden, March 13, 1865, SCHS.
90. Henry W. Feilden, letter to John Bennett, 1920, SCHS.
91. Feilden, *A Confederate Englishman*, xxxvii.
92. Kipling and Pinney, *Something of Myself*, 112–13.

93. Unpublished memoir in the Henry W. Feilden Papers, SCHS.
94. Henry P. Walker, letter to Nelly, January 18, 1861, SCHS.
95. Ibid.
96. Smyth, *Autobiographical Notes*, 572.
97. "American Crisis," 133.
98. Adams, *When in the Course of Human Events*, 72.
99. Dickens, *Letters*, 53–54.
100. Matthew Fontaine Maury (1806–1873), a Virginia naval officer and scientist who is regarded as the father of modern oceanography and naval meteorology.
101. Dorothy Walker, letter to Nelly, May 19, 1862, SCHS.
102. Dorothy Walker, letter to her sisters, February 21, 1863, SCHS.
103. Roman, *Military Operations of General Beauregard*, 2:140.
104. Ibid.
105. Ross, *A Visit to Cities and Camps*, 120–21.
106. Dorothy Walker, letter to Ellen, 1863, SCHS.
107. Dorothy Walker, letter to George Walker Jr., August 7, 1864, SCHS.
108. Henry P. Walker, letter to Nelly, January 9, 1864, SCHS.
109. Henry P. Walker, letter to Nelly, September 2, 1864, SCHS.
110. Dorothy Walker, letter to Ellen, March 13, 1865, SCHS.
111. Henry W. Feilden, letter to Julia McCord Feilden, March 12, 1865, SCHS.
112. Henry W. Feilden, letter to Julia McCord Feilden, March 13, 1865, SCHS.
113. McIver, *History of Mount Pleasant*, 90.
114. Hawkins, *Roger Pinckney*, 361.
115. Mitchel, *Jail Journal*, 43.
116. Johnson, *Defense of Charleston Harbor*, 224–28.
117. Taylor, *Leverett Letters*, 346.
118. Johnson, *Defense of Charleston Harbor*, 228.

Chapter 4

119. Feilden, *A Confederate Englishman*, 3.
120. Davis, *Papers of Jefferson Davis*, 15.
121. Smythe, *For Old Lang Syne*, 13.
122. Ibid.
123. Ibid., 7.
124. Carroll, *Report of the Committee*, 10.
125. Louisa R. McCord, letter to Sue, March 21, 1865, SCHS.
126. Louisa R. McCord, letter to Mrs. Smythe, March 23, 1865, SCHS.
127. Smythe, "Recollections," 69–70.
128. McCord, *Poems, Drama, Biography, Letters*, 382.
129. Smythe, *For Old Lang Syne*, 15.
130. Ladies' Memorial Association, *Memorials*, 8.
131. Ibid., 29–30.

132. Ibid., 16–17.
133. Ibid., 31–32.
134. Mount Vernon Ladies' Association, *Historical Sketch*, 5–6.
135. Ibid., 7–8.
136. Matthews, *Women of the South*, 285.
137. Mount Vernon Ladies' Association, *Historical Sketch*, 27.
138. Ibid., 48.

CHAPTER 5

139. Stokes, *Immortal 600*, 52.
140. Ibid., 54.
141. Ibid., 58.
142. Augustine T. Smythe, letter to his mother, September 8, 1864, SCHS.
143. Stokes, *Immortal 600*, 63.
144. Ibid., 70.
145. Carwile, *Reminiscences of Newberry*, 82–85.
146. Ibid., 85.
147. Ibid., 85–91.
148. Henry Summer, letter to Governor Magrath, April 22, 1865, SCDAH.
149. Sease, *Family Facts*, 83.
150. Henry Summer, letter to Governor Magrath, April 22, 1865, SCDAH.
151. John Fox, Affidavit, 1–7, Lexington County Museum.
152. Ibid., 9–10.
153. William P. DuBose, letter to Nannie Peronneau, April 28, 1862, SCHS.
154. William P. DuBose, letter to Nannie Peronneau, December 30, 1862, SCHS.
155. William P. DuBose, letter to Nannie DuBose, October 18, 1864, SCHS.
156. DuBose, *Faith, Valor, and Devotion*, xxvi.
157. William P. DuBose, letter to Nannie Peronneau, February 28, 1862, SCHS.
158. DuBose, *Turning Points*, 49–50.
159. William P. DuBose, letter to Nannie DuBose, October 15, 1864, SCHS.
160. Smythe, *Recollections*, 16.
161. Johnson, *University Memorial*, 457.
162. DuBose, *Reminiscences*, 149, SHC.
163. De Leon, *Belles, Beaux and Brains*, 162.
164. Sophia L. Haskell, letter, March 28, 1861, SCHS.
165. De Leon, *Belles, Beaux and Brains*, 163–64.
166. Ibid., 164.
167. Chesnut, *Mary Chesnut's Civil War*, 399.
168. Freeman, *South to Posterity*, 7, 204.
169. Haskell, *Haskell Memoirs*, ix.
170. Johnson, *University Memorial*, 463.
171. J. Moultrie Horlbeck, letter to Charles T. Haskell, July 11, 1863, SCHS.
172. Simms, *War Poetry*, 324.

173. Johnson, *University Memorial*, 461.
174. Edward McCrady Jr., letter to Charles T. Haskell, July 20, 1863, SCHS.
175. John Bachman, letter to Charles T. Haskell, July 31, 1863, SCHS.
176. Louisa S. McCord, letter to Sophia L. Haskell, July 16, 1863, SCHS.
177. Johnson, *University Memorial*, 463–64.
178. Witte, "Reminiscences," 2–5, SCHS.
179. Ibid., 5–7.
180. Ibid., 7–10.
181. *Report of the Committee on the Destruction of Churches*, 12.
182. Ibid., 10.
183. Ibid.
184. Ibid.
185. Ibid., 11.
186. Ibid., 13–14.
187. Ibid., 14.
188. Ibid.
189. Ibid., 5.
190. Taylor, *Leverett Letters*, 403.
191. O'Connell, *Catholicity*, 125.
192. Reznikoff, *Jews of Charleston*, 162.
193. Ibid., 163.
194. Ibid.
195. Smith, "The Ashley River," 4.
196. Duncan, "An Old-Time Carolina Garden," 804–05.
197. Ibid., 805.
198. Smith, "The Ashley River," 4–5.
199. Duncan, "An Old-Time Carolina Garden," 806.
200. Smith, "The Ashley River," 120–21.
201. Marcy, Diary, February 23, 1865, SCHS.
202. Ibid., February 24, 1865.
203. Leland and Greene, "Robbing the Owner or Saving the Property," 98.
204. Smith, "The Ashley River," 121.

BIBLIOGRAPHY

Adams, Charles. *When in the Course of Human Events: Arguing the Case for Southern Secession.* New York: Rowman & Littlefield, 2000.

Albergotti, William Greer. *Abigail's Story: Tides at the Doorstep.* Spartanburg, SC: The Reprint Co., 1999.

"American Crisis." *London Quarterly Review* 140 (January–April 1862): 124–45.

Andrews, Matthew Page. *The Women of the South in War Times.* Baltimore, MD: Norman Remington Co., 1923.

Baldwin, Agnes L. *A History of Spring Island, Beaufort County, S.C.* Spring Island, SC: self-published, 1966.

Burton, E. Milby. *The Siege of Charleston, 1861–1865.* Columbia: University of South Carolina Press, 1970.

Carroll, James Parsons. *Report of the Committee Appointed to Collect Testimony in Relation to the Destruction of Columbia, S.C., on the 17ᵗʰ of February, 1865.* Columbia, SC: Bryan Printing Company, 1893.

Carse, Robert. *Department of the South: Hilton Head Island in the Civil War.* Columbia, SC: The State Printing Co., 1961.

Carwile, John B. *Reminiscences of Newberry.* Charleston, SC: Walker, Evans & Cogswell, 1890.

Cauthen, Charles Edward. *South Carolina Goes to War, 1860–1865.* Chapel Hill: University of North Carolina Press, 1950.

Channing, Stephen. *Crisis of Fear: Secession in South Carolina.* New York: Simon and Schuster, 1970.

Chesnut, Mary Boykin Miller. *Mary Chesnut's Civil War.* Edited by C. Vann Woodward. New Haven, CT: Yale University Press, 1981.

Chester, James. "Inside Sumter in '61." In *Battles and Leaders of the Civil War*, Vol. 1, 50–74. New York: The Century Company, 1884.

Clarke, Philip G. *Anglicanism in South Carolina, 1660–1976.* Easley, SC: Southern Historical Press, 1976.

Confederate Military History Extended Edition: Vol. VI, South Carolina. Wilmington, NC: Broadfoot Publishing Co., 1987.

Confederate States of America. Provisional Congress. Committee on Foreign Affairs. *Report of the Committee on Foreign Affairs on the President's Message, Relating to the Affairs Between the Confederate and the United States.* Montgomery, AL, 1861.

Cooper, Dudley, and Spencer Murphy. "Unique Restoration of a Lost Library." *The State,* March 20, 1955.

Crawford, Samuel Wylie. *The Genesis of the Civil War: The Story of Sumter, 1860–1861.* New York: C.L. Webster & Co., 1887.

Dabbs, Edith M. *Sea Island Diary: A History of St. Helena Island.* Spartanburg, SC: The Reprint Co., 1983.

Davis, Jefferson. *The Papers of Jefferson Davis: Volume 9, January—September 1863.* Baton Rouge: Louisiana State University Press, 1997.

———. *The Rise and Fall of the Confederate Government.* New York: D. Appleton and Company, 1881.

Davis, W.W.H. *History of the 104ᵗʰ Pennsylvania Regiment.* Philadelphia: J.B. Rogers, printer, 1866.

De Leon, Thomas Cooper. *Belles, Beaux and Brains of the '60s.* New York: G.W. Dillingham Co., 1909.

DeTreville, Richard. *Sea Island Lands: St. Helena Parish and Its Citizens: A Few Chapters from a Faithful Unpublished History of the War of Secession.* N.p., n.d.

Denson, John V. *A Century of War: Lincoln, Wilson & Roosevelt.* Auburn, AL: Ludwig Von Mises Institute, 2006.

———. "Lincoln and the First Shot: A Study of Deceit and Deception." In *Reassessing the Presidency: The Rise of the Executive State and the Decline of Freedom,* edited by John V. Denson, 231–88. Auburn, AL: Ludwig Von Mises Institute, 2001.

Dickens, Charles. *The Letters of Charles Dickens: The Pilgrim Edition, Volume 10: 1862–1864.* New York: Oxford University Press, 1998.

DiLorenzo, Thomas. *Lincoln Unmasked: What You're Not Supposed to Know About Dishonest Abe.* New York: Crown Forum, 2006.

Doubleday, Abner. *Reminiscences of Forts Sumter and Moultrie in 1860–61.* New York: Harper & Brothers, 1876.

DuBose, William Porcher. *Faith, Valor and Devotion: The Civil War Letters of William Porcher DuBose.* Columbia: University of South Carolina Press, 2010.

———. *Turning Points in My Life.* New York: Longmans, Green and Co., 1912.

Duncan, Frances. "An Old-Time Carolina Garden." *The Century* 80 (October 1910): 803–10.

Dwyer, John J. *The War Between the States: America's Uncivil War.* Denton, TX: Bluebonnet Press, 2005.

Elmore, Tom. *A Carnival of Destruction: Sherman's Invasion of South Carolina.* Charleston, SC: Joggling Board Press, 2012.

Feilden, Henry Wemyss. *A Confederate Englishman: The Civil War Letters of Henry Wemyss Feilden.* Columbia: University of South Carolina Press, 2013.

Freeman, Douglas Southall. *The South to Posterity: An Introduction to the Writings of Confederate History.* New York: Charles Scribner's Sons, 1939.

Glatthaar, Joseph T. *The March to the Sea and Beyond: Sherman's Troops in the Savannah and Carolinas Campaign.* Baton Rouge: Louisiana State University Press, 1985.

Grinspan, Jon. "'Young Men for War': The Wide Awakes and Lincoln's 1860 Presidential Campaign." *Journal of American History* 96 (September 2009): 357–78.

Harris, Brayton. *War News: Blue & Gray in Black & White: Newspapers in the Civil War.* Washington, D.C.: Brassey's, 1999.

Haskell, John Cheves. *The Haskell Memoirs.* New York: G.P. Putnam's Sons, 1960.

Hawkins, Ellen Gray. *Roger Pinckney of England and South Carolina: A Family History.* Manquin, VA: H.W. Hawkins, publisher, 2000.

Hawks, Esther Hill. *A Woman's Civil War: Esther Hill Hawks' Diary.* Columbia: University of South Carolina Press, 1989.

Hays, Reverend P.D. *A Short Historical Sketch of the Parish from the First English Settlement in Carolina to the Present Time, 1712–1912.* Beaufort, SC: St. Helena's Episcopal Church, 1912.

Helsley, Alexis Jones. *Beaufort, South Carolina: A History.* Charleston, SC: The History Press, 2005.

Johnson, John. *The Defense of Charleston Harbor, Including Fort Sumter and the Adjacent Islands.* Charleston, SC: Walker, Evans & Cogswell, 1890.

Johnson, John Lipscomb. *The University Memorial Biographical Sketches of Alumni of the University of Virginia Who Fell in the Confederate War.* Baltimore, MD: Turnbull Brothers, 1871.

Kibler, James E. "On Reclaiming a Southern Antebellum Garden Heritage: An Introduction to Pomaria Nurseries, 1840–1879." *Magnolia: Bulletin of the Southern Garden History Society* 10, no. 1 (Fall 1993).

Kipling, Rudyard, and Thomas Pinney. *Something of Myself and Other Autobiographical Writings.* Cambridge, UK: Cambridge University Press, 1991.

Ladies' Memorial Association of Charleston, South Carolina. *Memorials to the Memory of Mrs. Mary Amarinthia Snowden.* Charleston, SC: Walker, Evans & Cogswell, 1898.

Leland, Harriott Cheves, and Harlan Greene, eds. "Robbing the Owner or Saving the Property from Destruction?: Paintings in the Middleton Place House." *South Carolina Historical Magazine* 78 (1977): 92–103.

May, John Amasa. *South Carolina Secedes.* Columbia: University of South Carolina Press, 1960.

McCord, Louisa S. *Poems, Drama, Biography, Letters.* Edited by Richard C. Lounsbury. Charlottesville: University Press of Virginia, 1996.

McIver, Petrona Royall. *History of Mount Pleasant, South Carolina.* Mount Pleasant, SC: Christ Church Preservation Society, 1994.

Mitchel, John. *Jail Journal; or, Five Years in British Prisons.* New York: Office of the Citizen, 1854.

Mount Vernon Ladies' Association of the Union. *Historical Sketch of Ann Pamela Cunningham.* New York: Marion Press, 1903.

O'Connell, Jeremiah Joseph. *Catholicity in the Carolinas and Georgia*. New York: D. & J. Sadlier, 1879.

Official Records of the Union and Confederate Navies in the War of the Rebellion. Washington, D.C.: Government Printing Office, 1894–1927.

Parker, Adam. "Saving History: Monuments Men Leader Helped Rebuild Middleton Place." *Post and Courier*, February 9, 2014, E1.

Payne, Barbara R. *Amazing Grace: The Parish Church of St. Helena, Beaufort, South Carolina: Three Hundred Years of History, 1712–2012*. Hilton Head, SC: Lydia Inglett, 2012.

Pepper, George W. *Personal Recollections of Sherman's Campaigns in Georgia and the Carolinas*. Zanesville, OH: Hugh Dunne, 1866.

Prentiss, William O. *A Sermon Preached at St. Peter's Church, Charleston*. Charleston, SC: Evans & Cogswell, 1860.

Quinn, James. *John Mitchel*. Dublin, IE: University College Dublin Press, 2008.

Racine, Philip N. *Gentlemen Merchants: A Charleston Family's Odyssey, 1828–1870*. Knoxville: University of Tennessee Press, 2008.

Ramsey, Frank. "Beaufort Public Library Once Fought for Survival." *Savannah Morning News*, July 16, 1953.

Report of the Committee on the Destruction of Churches in the Diocese of South Carolina During the Late War: Presented to the Episcopal Convention, May 1868. Charleston, SC: J. Walker, printer, 1868.

Reznikoff, Charles. *The Jews of Charleston: A History of an American Jewish Community*. Philadelphia: Jewish Publication Society of America, 1950.

Richmond Enquirer. "The 'Wide Awakes.'" September 28, 1860, 1.

Roman, Alfred. *The Military Operations of General Beauregard in the War Between the States, 1861–1865*. New York: Harper & Brothers, 1884.

Rose, Willie Lee. *Rehearsal for Reconstruction: The Port Royal Experiment*. New York: Oxford University Press, 1976.

Ross, Fitzgerald. *A Visit to Cities and Camps of the Confederate States*. London: W. Blackwood & Sons, 1865.

Salley, A.S., ed. *Minutes of the Vestry of St. Helena's Parish, South Carolina, 1726–1812*. Columbia, SC: The State Company, 1919.

Scharf, John Thomas. *History of the Confederate Navy from Its Organization to the Surrender of Its Last Vessel*. New York: Rogers & Sherwood, 1887.

Sease, Rosalyn Summer. *Family Facts and Fantasies*. New Haven, CT: privately published, 2000.

Sifakis, Stewart. *Who Was Who in the Civil War*. New York: Facts on File, 1988.

Smith, George Winston. "Northern Libraries and the Confederacy, 1861–1865." In *An American Library History Reader: Contributions to Library Literature*, selected by John David Marshall, 69–70. Hamden, CT: Shoe String Press, 1961.

Smith, Henry A.M. "The Ashley River: Its Seats and Settlements." *South Carolina Historical Magazine* 20 (1919): 75–122.

Smythe, Louisa McCord. *For Old Lang Syne: Collected for My Children*. Charleston, SC: privately printed, 1900.

Stokes, Karen. *The Immortal 600: Surviving Civil War Charleston and Savannah*. Charleston, SC: The History Press, 2013.

Taylor, Frances Wallace, Catherine Taylor Matthews and J. Tracy Power, eds. *The Leverett Letters: Correspondence of a South Carolina Family, 1851–1865.* Columbia: University of South Carolina Press, 2000.

Tilley, John Shipley. *Lincoln Takes Command.* Nashville, TN: Bill Coats Ltd., 1991.

War of the Rebellion: Official Records of the Union and Confederate Armies. Washington, D.C.: Government Printing Office, 1880–1909.

Wiley, Bell Irvin. *The Life of Billy Yank: The Common Soldier of the Union.* Baton Rouge: Louisiana State University Press, 1991.

MANUSCRIPTS AND ARCHIVAL SOURCES

Lexington County Museum (Lexington, SC):
John Fox Papers

South Carolina Department of Archives and History (SCDAH):
Andrew Gordon Magrath Letters, 1864–1865

South Carolina Historical Society (SCHS):
Augustine T. Smythe Papers
Edward H. Mellichamp Papers
Harriott Horry Ravenel Letter (February 24, 1865)
Henry Orlando Marcy Diary
Henry Pinckney Walker Family Papers
Henry Wemyss Feilden Papers
Isaac W. Hayne Correspondence
Louisa S. McCord Papers
Smythe, Louisa McCord. "Recollections of Louisa McCord Smythe."
William Porcher DuBose Correspondence
Witte, Rosa Glenn Reeves. "Reminiscences of the '60s."

Southern Historical Collection (SHC), University of North Carolina–Chapel Hill:
William Porcher DuBose Reminiscences

INDEX

ABOUT THE AUTHOR

K aren Stokes is an archivist with the South Carolina Historical Society in Charleston, South Carolina. She is a contributor to *The Civil War in South Carolina: Selections from the South Carolina Historical Magazine* and the co-editor of *Faith, Valor, and Devotion: The Civil War Letters of William Porcher DuBose* (2010) and *A Confederate Englishman: The Civil War Letters of Henry Wemyss Feilden*, published by the University of South Carolina Press in 2013. She has published two other books with The History Press: *South Carolina Civilians in Sherman's Path: Stories of Courage Amid Civil War Destruction* (2012) and *The Immortal 600: Surviving Civil War Charleston and Savannah* (2013).

Visit us at
www.historypress.net
...
This title is also available as an e-book

.

www.ingramcontent.com/pod-product-compliance
Lightning Source LLC
Chambersburg PA
CBHW060806100426
42813CB00004B/961